VICTORIAN DESIGNS FOR THE HOME

Charles Newton

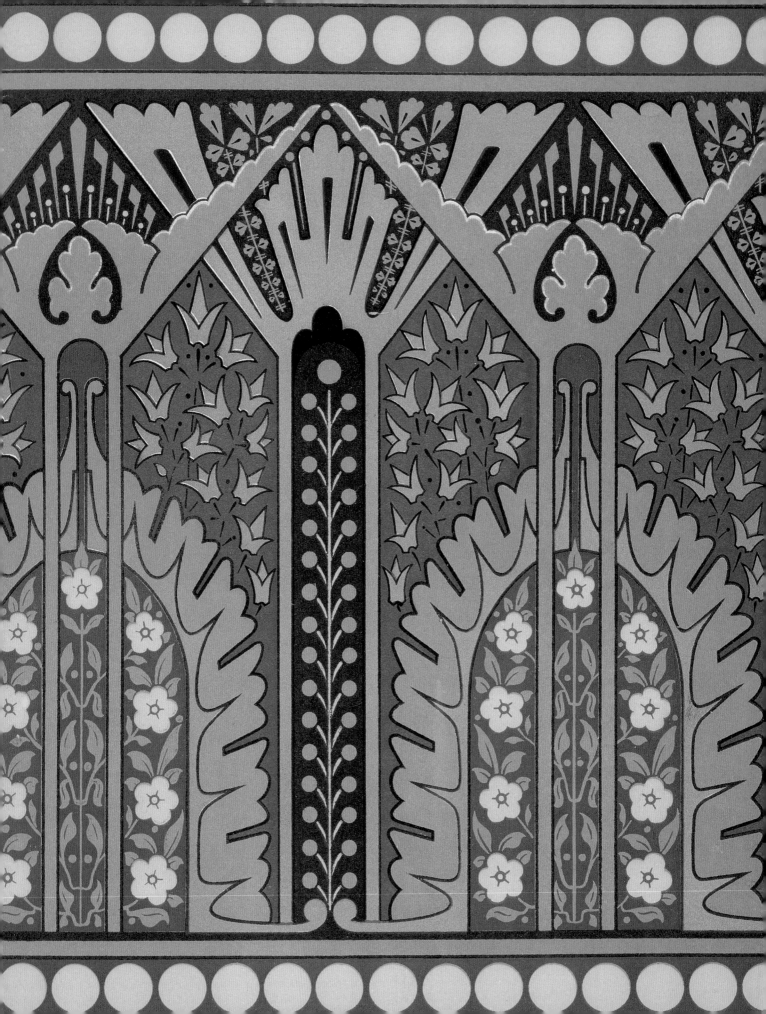

VICTORIAN DESIGNS
FOR THE HOME

Charles Newton

V&A PUBLICATIONS

To my daughter Lucy

First published by V&A Publications, 1999

V&A Publications
160 Brompton Road
London sw3 1HW

© The Board of Trustees of the Victoria and Albert Museum 1999

Charles Newton asserts his moral right to be identified as the author of this book

Designed by Sarah Davies
Photography by Dominic Naish, V&A Photographic Studio

ISBN 1851772847

A catalogue record for this book is available from the British Library

Printed in Hong Kong

Front jacket illustrations: *Detail of a view of a drawing-room, by Samuel A Rayner.*
E.1167-1948 *(see page 68); giltwood armchair, possibly by Gillows of Lancaster.* W.15-1985

Back jacket illustration: *The Yatman Cabinet, by William Burges.* CIRC. 217-1961
(see page 57)

Frontispiece: *Frieze design, by Christopher Dresser.* NAL 49 D9 PL.III *(see page 89)*

Contents

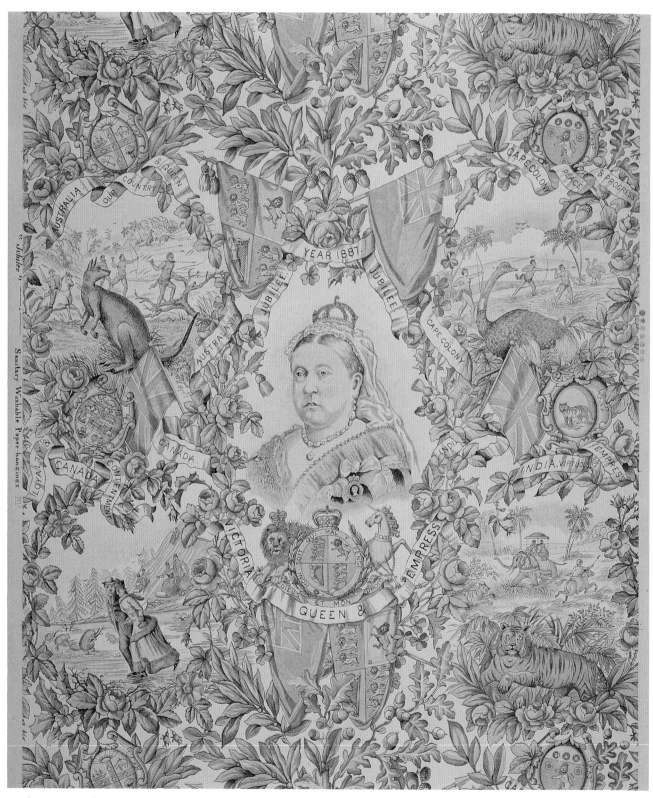

I. *(see page 14)*

Introduction

'What is the use of a book', thought Alice 'without pictures or conversations?'

Lewis Carroll's ALICE'S ADVENTURES IN WONDERLAND (1865) Ch 1.

In keeping with that warning from the heroine of a Victorian fiction, this book illustrates a selection of designs drawn from the collections of the Victoria and Albert Museum, London, and provides a commentary on them. Although the Victorian interior and Victorian decorative arts have been widely studied, designs on paper have received very little attention. Indeed, most of the designs in this book have never been published before.

The Victorian era was the first age to be fully (and sometimes painfully) aware of the infinite possibilities of design and manufacture. Huge advances in knowledge were made possible by applying scientific and systematic methods to all branches of learning. Research and development paid off more handsomely than could have been imagined. Yet progress has a price, and the disadvantage of a sudden abundance of ideas is the difficulty of assimilating them. This was particularly noticeable in designs for the decorative arts. An ever-improving knowledge of the various historic styles was developing; at the same time there was an unparalleled amount of manufacturing ingenuity and material wealth in circulation. This gave many more people the opportunity to choose a style in which to build and make. The problem was, which style?

There was no longer a set of accepted rules to help anyone to choose as there had been in the 18th century, when one or two styles existed within a single prevailing idea of taste. For the Victorians, each of many styles had some sort of claim to be employed. Because they were so prolific in energy and ideas, they suffered from an embarrassment of riches in the decorative arts.

In studying the origins of the various branches of Victorian design, we are immediately faced with problems of definition. Queen Victoria's accession in 1837 did not mark any significant change politically or socially, apart from changes in the relationship between the monarch and her ministers. In the world of things, much of what we regard as typically Victorian was already in existence in the two or even three preceding decades. A random

list might include steam carriages, steam boats, railways, gas lighting, the Gothic revival, roller-printing of textiles, jacquard weaving and spiral-spring upholstery. The span of Queen Victoria's reign, 1837–1901, is not a particularly convenient way of looking at developments in decorative design. Revivals of an eclectic mixture of past styles were well under way before Victoria acceded, and the foundations of the modern movement were being laid before she died.

What is the distinguishing mark of the Victorian period? What makes the Victorians *Victorian*? One answer is that it was the time when historicism reached its peak. Why did the Victorians employ a mixture of styles from the past instead of inventing something totally new? They had invented an impressive range of completely new things in other areas, and had immense confidence in their radically new designs for engineering, for example. Why did they not also find a completely new style of decorative art appropriate to the age?

The Victorian period has been called, with justice, the 'age of uncertainty'. The cause of this uncertainty is a matter of controversy among historians, but there can be no doubt that many thinking Victorians were torn by a conflict between tradition and a desire for progress. Progress was evident in every department of life and produced bewildering changes in social relations and the environment.

People facing change tend to cling to what they know, and this innate conservatism expressed itself at the beginning of the period in a desire for the good old days of medieval England. This emotional attachment to the past had immediate practical results. In wanting to simulate a baronial interior in a new house, a great lord of ancient family might not have been capable of a modern scientific or archaeological approach, but he did know what it was to be rich and powerful. Thus the 'feel' of the interior might have been closer to that of medieval homes, even if the lord himself could not distinguish between work of the 13th and 14th centuries. The triumph of industrialism made it possible for this feeling for the past to be realised on a grand scale, though the Victorians and their descendants have been continually derided for it by design pundits.

This longing was felt not only amongst the rich and powerful landowners, whose political power was being threatened by industrialists, but also among the landless workers driven to work in the factories. The past could be safely ignored by both groups when earnings were high, but when the going was hard all they had to cling to was a persistent myth of better bygone times. This dream of a pre-industrial past also enticed social reformers, who fought against such places as 'Hell-House Yard', the industrial district of Willenhall in Staffordshire, described by Disraeli in *Sybil, or the Two Nations* (1845).

Also unique to the Victorian age was the belief that social reform could be encouraged by the values of design and craft. Good design had a moral element, as opposed to the new cheap and flashy products that unprincipled manufacturers sold to easily seduced and uninformed consumers. Reformers hoped that a return to the sound principles of medieval craftsmanship would cure the ills of the modern world. This theme of a golden age permeates the whole century and underlies the thinking of A W N Pugin, John Ruskin and William Morris, as well as much later developments such as the Arts and Crafts movement, which continued well into the 20th century.

The progress of Victorian design cannot be described in one simple sequence, but can be thought of as a series of styles evolving in parallel. They sometimes competed, sometimes mingled, and usually started earlier and persisted longer than you might expect. The designs illustrated are therefore roughly arranged by style, although the divisions are not watertight.

There was a medley of styles already in use when Victoria came to the throne in 1837. The classicism of the 18th century, a style which found its inspiration in the architecture of ancient Greece and Rome, persisted throughout the 19th century. Also popular was another kind of grandeur and opulence, found in the French Baroque and Rococo styles of the 18th century. A mixture of elements of French origin became the mainstream style in the early years of Victoria's reign.

The Gothic style that had been popular with a mainly antiquarian elite in the 18th century developed strongly in Victoria's reign. Variants of this style were based on Tudor architecture and were called Elizabethan, or 'Old English'. The antiquarian furniture commissioned by Sir Walter Scott at the beginning of the 19th century was the inspiration for much Victorian Gothic furniture.

The need to build new churches for the rapidly increasing population in the early 19th century and a religious revival amongst the middle classes ensured that the church would be a major source of patronage for designers in the period. Unlike the frivolous Rococo-Gothic decoration of 18th-century houses and garden follies, the Victorian interest in reformed Gothic art had a deeply serious purpose, its proponents critical of what they considered less-than-authentic structure and details. The purer style's major advocate was Pugin, and a whole generation of architects and designers were influenced by him. The style was used even in the design of domestic objects, particularly furniture, but went out of fashion by the end of the century.

The need for reform in design and manufacture was an issue that finally attracted the attention of the government in the 1830s, although the necessity for it had been obvious for years before. The French, Britain's main trading rivals at the time, boasted many highly skilled draughtsmen and designers, whereas manufacturers in Britain complained of a lack of com-

petent designers able to provide suitable drawings for the ornamentation of their products. Pressure from various design reformers found allies in government, and government schools of design were set up. These gave some of the design reformers a platform to push through their ideas in practical form, and their influence finally made an impact on the mainstream of design. Henry Cole and his colleagues, endorsed by Prince Albert himself, managed to establish in the 1850s a national system of training in design and equipped succeeding generations of designers with the basic technical skills that Britain had lacked.

Mainstream Victorianism from the middle of the century onwards is the hard-to-define (but easily recognisable) look that most people think of as the essential style of the age. It consists of an eclectic mix of Renaissance styles, naturalism and another revival of Rococo, with French tastes generally still predominating. Its extreme form is the style of the specially made grand objects exhibited at the Great Exhibition of 1851, where historicism and eclecticism ran riot and provided something to rebel against for an idealistic younger generation.

From the 17th century there had been ephemeral fashions in Britain for two-dimensional exotic patterns influenced by Indian, Chinese or Islamic ideas, mostly in textile and wallpaper designs. Although Victorian architects tried to introduce exotic elements into building design they were not generally taken up and never became fashionable, with a few spectacular exceptions, except for interior decoration. Flat pattern inspired by Indian and Middle Eastern models was advocated by members of the design establishment such as Owen Jones, but apart from the notable exception of shawl design, it was not fully assimilated or developed further. Some Victorian wallpaper and textile designs were based on complex abstract Islamic patterns derived from Koranic bindings and ornament on buildings, but naturalism remained much more popular.

The critical denunciation of mainstream Victorian design was started early in the period by the Victorians themselves. William Morris was physically ill when, at the age of 17, he saw the products on offer at the Great Exhibition of 1851, and he spent the rest of his life combating what he saw as the decline in the quality of art and life. He rejected as frivolous the mixture of 18th-century French styles that was still generally popular; he despised the 'Greek' style of neoclassicism which had persisted in his youth, he loathed the crude unarchaeological Gothic that seemed to travesty his own preference for the pure forms of late medieval art that Pugin had advocated. He passionately wanted to restore medieval craftsmanship, but in a modern form, by taking inspiration from the examples of the past. Morris believed that only the craftsman's pleasure in making what was beautiful or useful could bring this about. Mechanically reproducing

frivolous things at the tyrannical pace of the machine would bring only dissatisfaction and unhappiness, as well as bad art. John Ruskin's scathing attack on the unfeeling commercialisation of life, art and design influenced Morris and many others, and his attitudes persist to this day amongst those who practise the crafts.

As what we now think of as the modern world started to emerge in the expanding cities, a consciousness formed that there was a need for a new art, that new forms of painting, new ways of representing the world, must also be developed. The style leaders of the 1870s, artists such as J McNeill Whistler and Frederick Leighton, were highly educated, self-conscious of their aesthetic leanings and international in their outlook. The opening up of Japan and the subsequent stream of unfamiliar objects and images seen at international exhibitions or for sale in importers' shops enabled these specialised consumers to distance themselves from the vulgar herd who were content with what British commercial manufacturers provided for them. These Aesthetes, as they were called, even dressed aesthetically, and in certain cases their excessive preciousness made them an easy target for philistine satirists. This Aesthetic movement included several highly talented architects and designers such as William Godwin and Thomas Jeckyll, who were able to make coherent but highly eclectic mixtures of, for example, Gothic and Japanese motifs, without apparent incongruity.

The Arts and Crafts movement began in the 1880s, derived from a small group of architects and designers who had been influenced by Pugin, John Ruskin and William Morris. In many cases these Gothic architects had trained together. Their attitude towards craftsmanship was based on their idealised view of anonymous medieval craftsmen working in guilds. They rejected what they saw as excessive and useless ornament and modern over-reliance on the machine. A desire for simplicity and honesty of design, combined with the use of authentic, traditional materials, is the hallmark of this style. This creative nostalgia was increasingly mingled by their followers with utopian schemes and a desire to avoid the industrialised cities by retreat to the countryside.

The new art that progressive painters and their Aesthetic supporters had encouraged finally manifested itself in decorative art at the end of the century as a movement called by the French 'Art Nouveau'. This was indeed a new creative force, but it expressed itself in different forms in different places. It was partly British in origin, although designers in Britain later tended to distance their work from the more exuberant continental forms, which were at their height between about 1895 and 1905.

The Legacy of Victorian Design

The medley of styles running concurrently in the Victorian period had caused disputes among their various adherents. For example, Pugin and his Gothic followers were dismissive of the classicists; the Aesthetes derided the hearty philistines who liked opulent French fashions; devotees of the Arts and Crafts recoiled in horror at gimcrack machine-made furniture. It seems inevitable that supporters of a new fashion attack the previous style and are then in turn assailed by partisans of the next.

At least the combatants in this battle of styles in the 19th century viewed their opponents seriously, but in the early 20th century the morally earnest Victorians were subjected to the most destructive force of all, mockery, which was a vicious weapon in the hand of experts such as Lytton Strachey. His *Eminent Victorians* (1918) poked ironic fun at Victorian heroes and heroines, so that it seemed they could not be taken seriously again.

After Victorian heroics and idealism had finally faltered in the technological horrors of trench warfare in 1914, many of the deeply cynical young survivors wanted a new age. In 1917 the poet and soldier Robert Graves, who had been seriously wounded and was recuperating at Osborne, Queen Victoria's retreat on the Isle of Wight, started what must have been one of the first attempts to mock the Victorian age. He founded a satirical society with his fellow officers for 'the study of the Life and Times of Prince Albert'. Poor Albert was regarded by intellectuals as deeply, and by now unfashionably, serious and has never been fully rehabilitated in the eyes of the British public. This mockery would not have mattered to design history at all except that the propagandists who objected to the narrow moralising attitudes (as they saw it) of the average middle-class Victorian household also ridiculed, in the most devastating way, a selection of the material achievements of the Victorian age. It was as if the furniture and textiles somehow were scapegoats. They presented an easy target as they had fallen from fashion.

The critical savaging that the Victorians and their artifacts received coloured the opinions of the generations educated between 1901 and 1951 to such an extent that 'Victorian', the word itself, in certain contexts was a kind of insult. The result has been that although most of their achievements have been recognised (they manifestly invented the modern world by their efforts) their art and particularly their decorative art was viewed as the antithesis of all things modern, and therefore bad and mistaken.

The history of design, a relatively new subject in universities, used to start with the Great Exhibition and William Morris in the 1850s and refers only glancingly to any earlier period. The reason for this is usually thought to be that Nikolaus Pevsner described William Morris as one of the *Pioneers of the Modern Movement* (1936) in his book of that title. It was assumed that modern

design was the only true and inevitable consequence of what went before, and that other kinds of design were evolutionary bypaths that led nowhere. The other Victorian ideas that Morris had attacked from the 1850s onwards were considered obsolete and as dead – even as faintly comic – as the Dodo.

There is another reason why those early years were avoided by design historians and are consequently more difficult to understand. The interests, obsessions and mind-set of the early Victorians were very different from those that concern most people now. Of course many of the ideas that the Victorians held have evolved into things we still recognise, although they have been modified. But the ideas that have completely died out, with no obvious modern counterpart, are more difficult to grasp. It is easy for us to see why the Victorians enjoyed a naturalistic floral textile design. Most people still do. But if you want to know why a rich man or woman commissioned a huge Gothic sofa covered in armorial decorations, then you need to understand the context of ideas that produced it.

A reassessment of Victorian decorative art has been gathering momentum since the 1950s. Studying designs for things makes a useful start. Everything man-made is designed, from the humblest household object to the most elaborate machine ever constructed. Yet we often still take for granted that something just is, and rarely think about the design process that went into it. Every 19th-century object, every teaspoon, net curtain and railway bridge was designed, just as things are now, and often in a very similar way. How exactly did our ancestors get from an idea to a finished object? What was the preliminary stage that preceded the manufacture of a vast piece of Victorian furniture, or a small piece of embroidery? The traditional and most frequently used method was that of making drawings.

Designs on paper are a pragmatic device, part of the process of getting something made. Incidentally many of them look attractive, and that was an essential part of their purpose. If they did not appeal as drawings to the potential patron or customer, then the idea would not sell. They are not fine art, although often they were made by artists. Most manufactures depended on drawings of some sort. Although it is possible to design without drawing, and some interior designers could communicate their ideas to their craftsmen in words only, it was comparatively rare. Our word 'design' is derived from the Italian *disegno* which meant both a drawing of any kind, and something close to our modern use of the word 'design'.

The Victorians believed that good drawing skills were the first step in good design. They consciously attempted to rejoin the fine and applied arts, to make an 'art object', to restore the 'art' that the machine was accused of leaving out. Thus the Victorian design establishment particularly encouraged painters to provide designs, and that is why so many of their design drawings, as represented in the following pages, are attractive in their own right.

1. *(page 6)* Queen Victoria's Golden Jubilee, anonymous

Wallpaper; colour print from engraved rollers 1887. Given by the Royal Scottish Museum. E.791-1970

This wallpaper portrait of Her Majesty tells us much about Victorian attitudes, obsessions and achievements. The importance of the Empire, the high-point of colonialism, the long and prosperous reign and political stability are all celebrated directly or implicitly. Yet there is also the peculiarly unashamed Victorian mixture of science and art, education and sanitation. The border of the paper is stamped "Jubilee" – Sanitary Washable Paperhangings B.V'. Cleanliness was next to Godliness, certainly in middle-class Victorian homes. Yet the uneasy mixture of elements that we perceive did not concern most of the consumers who bought this paper for their rooms.

The design reformers from Pugin and Sir Henry Cole onwards would have hated this particular design, as it broke every rule of good taste in applied art they had tried to formulate. For example, Pugin would not have liked the crude drawing and un-Gothic scenes of modern life; Henry Cole, Owen Jones and the design establishment of their time were advocates of flat stylised pattern and against the 'false' perspective of inappropriate figurative subjects. But their efforts were mainly ignored by the growing mass of consumers. In 1887 you could have bought magnificent wallpapers by William Morris, Walter Crane, Lewis F Day and even the young C F A Voysey, yet most of the population did not do so. The divide between the design-conscious elite and the ordinary citizen was then very wide.

In studying Victorian design history and the way that museum design collections have been built up, it is obvious that this elite taste was until very recently the main object of concern and study. This wallpaper or one similar could easily have been bought, literally for pennies, in 1887 by the Victoria and Albert Museum. It is significant that it was not given to the museum until 1970, when the academic study of Victorian popular art had become respectable.

2. Design for the paddle-steamer Prince Leopold, by Barclay Curle & Co, Glasgow

Pen, ink and watercolour 1876. The drawing shows part side elevation, longitudinal section, half-plans of upper and lower decks, position of engines and lay-out of passenger accommodation. E.655-1987

This is one area where Victorian design was not in dispute. It was confident, forward-looking, world-leading, unselfconscious, appreciated by most of the population and it led seamlessly into the modern world. There is latent in this design an unstated aesthetic that engineers had steadily developed, and of which they were proud. This aesthetic appeal was never separated from the process of design, but was evolved at the same time as engineers, over generations, struggled to make something harmonious out of the conflicting demands of space restrictions, weight limits, deck heights, hull shapes and engine configurations.

Within the steamer, however, the interiors for the passengers were chosen off-the-peg from a reassuring variety of historic styles, just as if the steamer were a secure building on land. On the bigger boats, Rococo or Tudor interiors were common, and apart from the distorted proportions caused by the low ceilings, you could (when the sea was calm) imagine yourself safe on land. Within the boat's hull, there was the same Victorian dilemma regarding which style should be chosen to suit the modern age, whereas on deck it had already been decided.

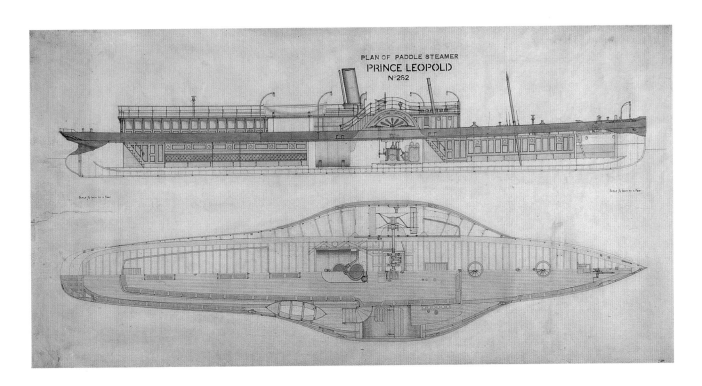

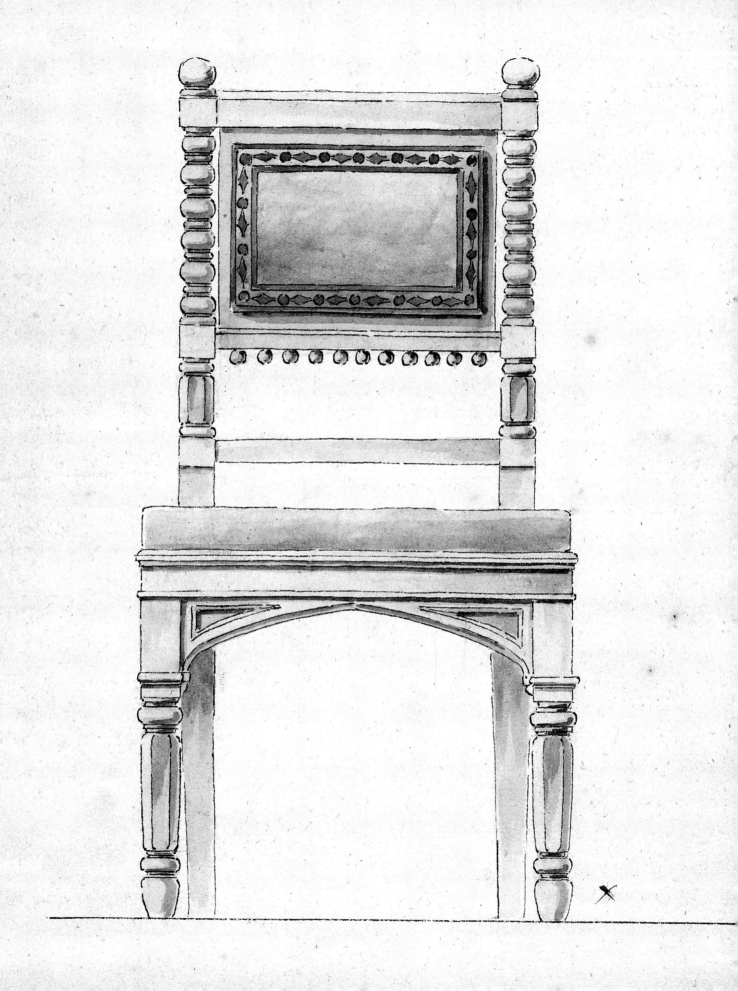

3. Design for a chair in the Gothic manner, by William Atkinson and Richard Bridgens (worked early 19th century)

Pencil and watercolour 1818. E.758-1982

This design for a chair is included even though it does not strictly belong in a book about Victorian designs. It looks at first sight quintessentially Victorian, yet it was actually designed in 1818 by William Atkinson and Richard Bridgens for Sir Walter Scott the novelist. Scott wanted antiquarian furnishing for his house at Abbotsford, near Melrose in Scotland, and commissioned George Bullock, the Regency cabinet-maker, to provide new but appropriate furniture to suit the imagination of this great novelist and recreator of medieval times. The solid construction and simple yet sophisticated design based on medieval forms (but absolutely modern), set a pattern imitated by many for the rest of the century. This kind of Gothic design persisted because it answered various needs, and was in full flow when Victoria was only a child. Yet if the chairs made to this design miraculously appeared unrecognised in an antique shop now, how many people would realise their early date?

I

Persistence and Change

Sir, you are the paymaster, and must therefore be pattern-master; you choose the style of your house just as you choose the build of your hat; – you can have a Classical, columnar or non-columnar, arcuated or trabeated, rural or civil or indeed palatial; you can have Elizabethan in equal variety; Renaissance ditto; or, not to notice minor modes, Mediaeval in any one of the many periods and many phases, – Old English, French, German, Belgian, Italian and more.

Robert Kerr's THE GENTLEMAN'S HOUSE (1864),
quoted in Joanna Banham, Sally Macdonald and Julia Porter's
VICTORIAN INTERIOR DESIGN (1991).

BY 1837 THERE WAS a substantial number of styles and variants in architecture and interior design to choose from, and it was generally admitted that, apparently for the first time, the age did not have a style that could properly and exclusively be called its own. Nostalgia for a British golden age enabled architects to build and design in a quaint Tudor style, or apply Gothic forms to new kinds of furniture. For those who looked beyond the Channel, various French styles were given a new impetus after the Revolution and the restoration of the monarchy in France. The Rococo style of interior design was revived in the 1820s, and a number of

British firms made imitations of French Rococo ceramics in the same period. At first an exclusive style, by the 1850s it had become the norm of middle-class taste.

The Regency neoclassical style of the late 18th century still persisted, including the plainer elements of Grecian style, particularly in simpler furniture designs. Middle-income families, who could not furnish a house in one expensive attempt, lived with a mixture of old and new out of necessity, as did many of the wealthier families who had inherited grand pieces of furniture and did not wish to relegate them to the attic. Designs for silver incorporated Baroque and Rococo forms combined with a growing naturalism. Textile designs looked back to 18th-century forms, but occasional bold experiments produced fabrics whose abstract style does not fit easily into any category.

4. Drawing-room at Haddon Hall, by Joseph Nash (1808–78)

Lithograph, coloured by hand. A plate from The Mansions of England in the Olden Times *(published in parts 1839–49).* E.5632-1903

Joseph Nash was a painter and lithographer who produced high-quality hand-coloured prints of important events and buildings. He was first famous for this series of illustrations of historic house interiors, and later produced a popular series of pictures of the Great Exhibition of 1851. There was an intense mood of nostalgia for the feudal past in Britain, mingled with Victorian practicality. So if you had the wealth, and many did, you could re-create the past in your own house in the style of your dreams – or at least of your imagination.

Nash was tapping into a vein of fantasy which could be made real. He pioneered a way of representing historical interiors peopled with figures doing appropriate things, and this was a key factor in their appeal. The face of Tudor or earlier Britain looked something like his pictures, though no doubt his view was sanitized. The crucial point was that his images could be used by architects and designers to make interiors with similar qualities to these reconstructions.

At that period there had been no scientific research (in the modern sense) as to what had actually existed within the fabric of the buildings, nor what the furnishings were, nor the colours in which the interiors had once been painted, although surviving medieval objects and architecture were increas-

ingly eagerly studied or collected. Yet it did not matter, as energy and enthusiasm for a style that looked suitably old and magnificent achieved the desired effect. Most people then believed that their reconstructions were accurate enough, and it is only with hindsight that we can see how Victorian as well as Tudor they look.

5. 'Our Drawing Room at York', by Mary Ellen Best (1809–91)

Watercolour c1838–40. Private collection

Pictures of relatively modest interiors are surprisingly rare, and this is one reason why the lay-out and decoration of rooms in the early Victorian period are often misunderstood. In the 1930s, when the first serious attempts to reassess 19th-century interior design were made, survivors from the era were asked about their childhoods. What they remembered clearly (and sometimes with horror) were the dark, deeply cluttered, densely packed interiors of the wealthier homes of the 1880s. In fact, earlier room settings still retained a relatively open look.

Mary Ellen Best made a very unusual series of paintings of interiors in York in the 1830s. This painting of a drawing-room at No 1 Clifton, York, was in a house she rented after the death of her mother in 1837. As an independent woman of means, she decorated it to her taste and moved in at the end of November that year.

The large-patterned wallpapers and carpet in the drawing-room are in fact a Regency taste which persisted into this period. By 1837 there was more emphasis on comfort and a richer effect in such things as upholstered sofas and armchairs. The simpler, rather plain 'Grecian' furniture that survives from this era is still quite common. Yet the really showy elements of the room, particularly the wallpaper, carpet and curtains which would strike the senses immediately, have hardly survived. It is difficult to imagine the sheer size, richness and brilliant colouring of the textile and wallpaper patterns.

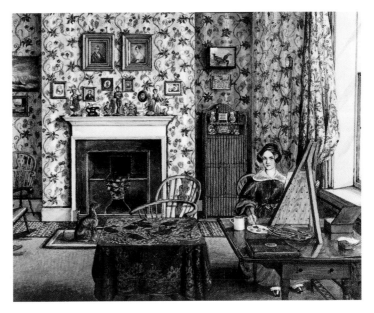

6. Details from design for a *vis-à-vis*, by Lewis Nockalls Cottingham (1787–1847)

Pencil and watercolour 1842. E.520-1951

The massive lines of this remarkable piece of furniture lay it open to all the adverse criticism that was levelled, so often unfairly, at Victorian furniture. The triumphant growth and influence of a low-key unadorned modernism in the 20th century prevented this lavish style from being taken seriously. Yet in its time and in its context it was the good and obvious solution to several problems. John Harrison, owner of Snelston Hall, (designed by Cottingham in a Gothic manner in 1828) wanted grand furniture in the same Gothic style that would suit the large rooms. He preferred it to be comfortable and deeply padded with horsehair, in the upholsterers' fashion of the day, and covered in fabrics of rich and pleasing fashionable colours.

The *vis-à-vis* (French for 'face to face') sofa was a relatively new and practical solution to the difficulty of talking face to face with someone while sitting on the same piece of furniture. Cottingham called it a 'conversational sofa', and it was a useful compromise between the awkward intimacy caused by sitting next to someone you knew (but not very well) and the rather confrontational formality of sitting on separate chairs.

Cottingham had to create new forms because nothing like a sofa, let alone a *vis-à-vis*, had actually existed in medieval times. (Deeply padded upholstery was introduced only in the 1820s.) For the ornament he used authentic Gothic details taken from architecture in castles and churches. So this sofa was a perfectly modern design incorporating pleasing details carefully drawn from surviving historic work. John Harrison was getting the best of both worlds, by indulging his nostalgia for the past, combined with the latest fashions and technology in upholstery. He was obviously more interested in comfort and fashion than strict Gothic authenticity.

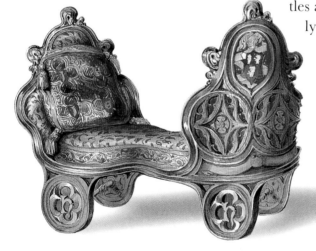

This brilliantly coloured presentation drawing was used to sell the idea to the patron, who would be expected to pay a substantial sum for the craftsmen to make this large piece. They would not necessarily need more detailed drawings, as many were skilled enough to carve from just a general outline of what was required. Why John Harrison was emotionally drawn to, and chose, the Gothic style is not known, but his interest could just as easily have been fuelled by reading the historical novels of Sir Walter Scott as by wanting to be at the forefront of fashion.

7. Design for embroidery, by Sarah Bland (worked first half of the 19th century)

Pencil, water- and body colour c1840. E.372-196

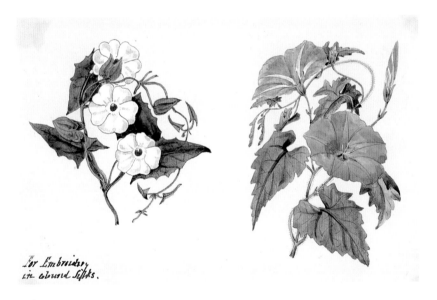

This sheet is typical of the repertoire of design ideas built up by embroiderers. Useful floral patterns were traced from earlier embroideries or from book illustrations, adapted and modified to suit the particular textile. Naturalistic floral sprigs had been the main source to which the embroiderers had returned for hundreds of years, although many experiments had been made. These amateur designs were made for personal use, and many were bound or collected in albums and preserved through the generations of one family, and so we know the names of the embroiderers. The paradox is that the names of professional designers have often been lost in the anonymity of a business. The albums are a fascinating compendium of design ideas, very often the only surviving record of the work, as the textiles produced from them have perished with time.

8. Piano, made by Collard & Collard

Oak c1845. w.20-1974

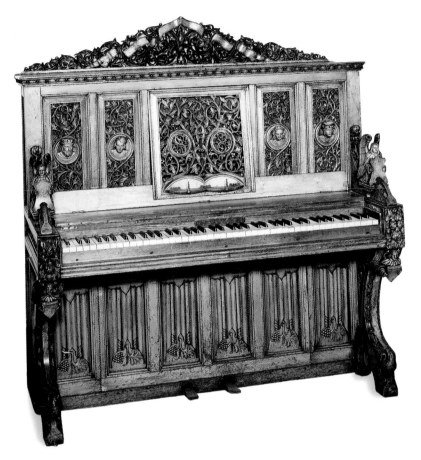

The square piano was an 18th-century invention; upright pianos are a 19th-century development. They became so popular that by the end of the 19th century virtually every respectable household had one. The large size and unconventional shape of the case meant that it was often the most prominent piece of furniture in the room. Socially, it was important as it was used for entertaining guests as well as the family; playing the piano was a polite accomplishment, especially for the daughters of the household. The problem, particularly for the owners of houses built or furnished in the Tudor style, was that pianos had not existed then. A suitable style had to be developed so that the instrument would blend with the rest of the furniture. Elements of Gothic detail were copied from late medieval church architecture and furnishings. A similar problem occurred in the 20th century with the newly invented radio sets. At first they were often encased in 17th- or 18th-century style cabinets, to blend with their surroundings, before a new style, made in modern materials such as Bakelite and other plastics, was finally developed.

9. Table, probably designed by Thomas Willement (1786–1871)

Oak c1838. From Mamhead, Devonshire (a house designed in the Tudor style by Anthony Salvin in 1827–33). Maker unknown. W.5-1973

Thomas Willement, best known as a stained-glass designer, was responsible for some of the decorative schemes at Mamhead House. It is assumed that he adapted this design from a similar pattern published by Richard Bridgens in his book *Candelabra and Interior Decoration* (1838). The table is ornamented with fretwork, strap work, bosses and pendants which are derived from Tudor sources, but no real piece of Elizabethan furniture actually looked like this. The purists who later insisted on a more 'archaeological' approach to the re-creation of Gothic furniture condemned the early Elizabethan revival as a frivolous mixture of elements. Yet this style was popular and remained so, being a design choice that persisted to the end of the century. There was even a revival of this revival in the 20th century, the so-called 'Jacobethan style' which survived into the early 1950s to the utter horror of the design reformers behind 'utility' furniture.

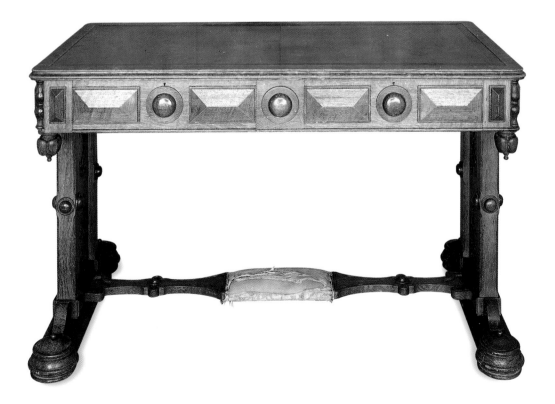

10. Designs for ornamental chimney pots, by Charles James Richardson (1806–71)

Pencil and watercolour 9157E, 9157F.

These strange-looking objects, although architectural, are included to show the uneasy union of decorative art, science and a historical style. We call them chimney pots, but their contemporary name was chimney heads, and

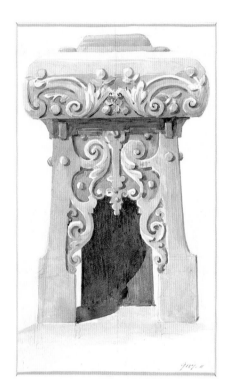

they were made of metal or fired clay. These ornate structures, in a picturesque style partly classical, partly Elizabethan revival, are also scientific attempts to solve the perennial problem of smoke being blown back into the room by a down-draft in the chimney. This explains the cut-away section, a kind of vent at the base of these structures, which was to aid and direct the gust of wind to pull up the smoke as it was forced past the lip of the chimney head. The shapes and interior profiles of the chimney heads were critical to their efficient function, and there were many attempts to perfect the technique.

Richardson, a pupil of the architect Sir John Soane, designed structures in a picturesque mixture of styles, and these chimney heads would have been intended for houses in a historic revival style. Needless to say, no object had looked like this in earlier times, but picturesque houses needed picturesque detail, and it did not matter that there was no direct prototype. Efficient chimneys were always a problem to architects of the classical revival, as ancient Roman buildings did not have them. The opportunity to make them a decorative feature on Gothic, Elizabethan and of other kinds of revival styles was too tempting to resist, especially as elaborate chimneys had been an integral part of many medieval and 16th-century buildings. Throughout the 19th century chimneys were often deliberately exaggerated in height and size to become quaint ornaments to the whole structure, although tall chimneys did also improve the draught. Richardson himself had published a book in 1837 entitled *A Popular Treatise on the Warming and Ventilation of Buildings*.

11. Design for a plinth, attributed to William Gibbs Rogers (1792–1875)

Pencil and watercolour c1840. E.1666-1979

It used to be believed that the introduction of machinery was the cause of the perceived decline in design standards and the skills of craftsmen in the 19th century. The truth is far more complex. For most of the century skilled craftsmen were more in demand than ever. The market for more grandiose objects for ostentatious display was increasing; luxuries were required by a growing population wealthier than ever before. It is true that in the 1830s Thomas Jordan did invent a patent wood-carving machine which was used for the elaborate panelling in the new Palace of Westminster, but extremely skilled wood-carvers were still required to finish off the work. The machine could do only so much of the roughing-out, and the final surface details were hand-cut as they had always been.

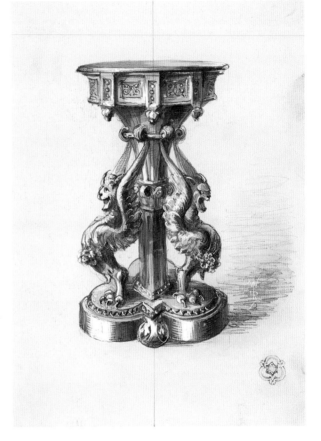

William G Rogers was a brilliant wood-carver who could carve in any style required. He would happily produce severe classical moulding for a gentlemen's club, picturesque Tudor for a new country house, a playful Gothic table for an antiquary with a sense of humour, and even a good copy of a Grinling Gibbons carving. His son William H Rogers was also a talented designer in various media, and seems to have shared his father's outlook on the past.

The design for an eccentric Gothic plinth shown here is typical of the way early Victorians cheerfully combined various elements in an unhistoric manner. The trilobate (or clover-leaf-shaped) base of the plinth is a Gothic shape, but was not used in this way for medieval furniture. The winged devil-headed grotesques with one foot ('monopode' is the technical term) were derived perhaps partly from medieval manuscript decorations and partly from classical lion monopode tables, and have been given an alarming three-dimensional form. Essentially this is a classical table converted to a Gothic plinth for a sculpture or something similar.

12. Designs for consoles carved with a lion's head, by William Gibbs Rogers (1792–1875)

Pen and ink and pencil c1840. E.1696-1979

These consoles or architectural supports were made for a gentlemen's club in Pall Mall, London, and the inscription also states that they were 'carved in maple wood for the Drawing Room'. The design develops from a scribble in a whirl of lines on the left into a very free and even frivolous lion mask in the centre. There is a return to sobriety in the side elevation and the front of the bracket, on the right, obviously based on examples from classical antiquity. It is not a solemn exercise in re-creating the antique to archaeological standards, but a design for the fittings for a club, a place of rest, recreation and pleasure. Drawings such as these are a reminder of the informal processes of design in its early stages. It is sometimes difficult to realise how free the play of the designer's imagination had been, when looking at the carved solidity of the finished sculptural decoration.

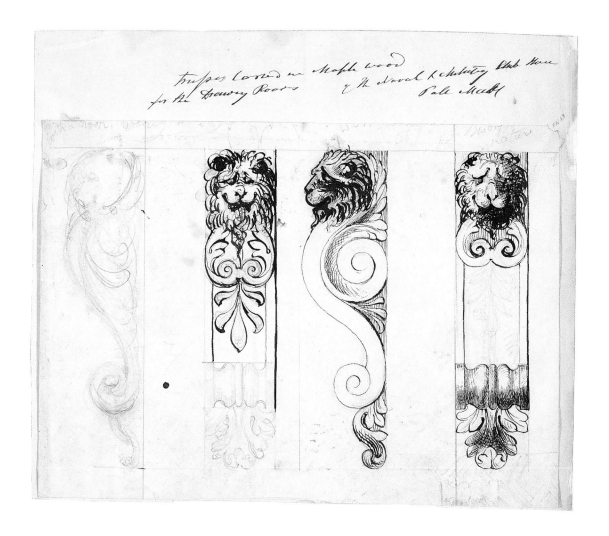

13. Design for a presentation candelabrum, by John Jones (worked mid-19th century)

Pen and ink and watercolour 1845. Designed for Matthew Uzielli, Hanover Lodge, Regents Park, London. E.798-1978

This drawing of an elaborate silver candelabrum is heavily annotated to show what was required by the client, and also indicates the makers, Storr and Mortimer, and the enormous price of £1,000. (In 1845 this sum would have bought a good-sized house.) John Jones was the son of Francis Jones, who had taken over the firm of Blades, the famous cut-glass sellers, around 1830. They numbered among their clients such notables as Sultan Mahmud II of Turkey. John Jones provided designs for luxury objects in various media, though glass objects predominate in the surviving designs in the V&A. This centrepiece looks back to late Georgian examples, themselves based on 18th-century grand French styles, mingled with the soft naturalism of early 19th-century British sculpture. The miniature allegorical sculptures arranged round a stem are very like sculptors' work of the 1820s. The branches of the candelabrum have naturalistic decorated branches of a kind of acanthus leaf. The base is partly in the Baroque style with symmetrical branches of acanthus leaf, and partly in a revived Rococo style with rather fat 'c'-shaped curls, typical of the 1840s.

Matthew Uzielli was a famous 19th-century collector of paintings and decorative art, the most famous object in his collection being Piero della Francesca's 'Baptism of Christ', now in the National Gallery, London.

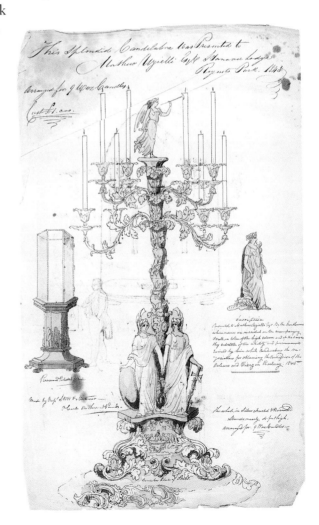

14. Design for a roller-printed cotton, by James Mitten (1812–54)

Water- and body colour c1840. E.938-1986

The rapid development of roller-printing on cotton from about 1810 meant that, combined with other recent developments in textile machinery and the increased range of dyestuffs, the demands of the home market and the export trade rocketed. The consequent need for designers was huge, but we know very little about them as individuals, as usually not even their names were recorded. James Mitten, probably a descendant of a Huguenot, was fortunate that his family preserved his work and thus his name. Cottons of this early period do not often survive, as cotton rags were recycled as raw material for paper or 'wipes' for machinery.

This is a great pity as many of these early small-element patterns appear especially intriguing and strangely 'modern' to us. Their apparent modernity results from a 19th-century taste for stylisation and geometric patterns, and did not have the same foundation as modernism at all. There was no conscious desire to reject the past by simplifying or abolishing conventional floral ornament. The Victorians wished to extend the repertoire of patterns in the face of a huge demand for novelty.

Some of the weirder patterns may have been based on ideas suggested by Sir David Brewster's invention of the kaleidoscope in 1814, and other scientific images, such as drawings made of microscopic organisms.

As roller-printed cottons were a recent development, the constraints of tradition did not apply strongly to them. The pattern-makers were market led and the printed cottons represented what the public wanted at that exact moment. Literally thousands of patterns were produced each year and changes could be made very rapidly. Commentators in the 1840s speak of the restless desire for novelty which kept teams of textile designers working ceaselessly. James Mitten's patterns are very carefully drawn and of high quality, and show a great range of invention. Similar patterns were revived by Laura Ashley in the 1960s. Ironically they appeared and appealed as novelties again, simply because virtually all trace of the original textiles had been lost or the designs remained, known to only a few, in museum collections.

15. Design for the decoration of a room in a public building in the Pompeian style, by John Gregory Crace (1809–89)

Pencil, pen and ink, water- and body colour c1860. E.783-1981

With the rapid increase in the population and the mushroom growth of industrial towns in Britain, new and bigger civic buildings and places of assembly were required. One of the favoured styles for their interior decoration throughout the whole of the 19th century was the so-called Pompeian style. Excavations at Rome, Pompeii, and at Herculaneum continued to reveal a wealth of fantastic painted decorative details. They had been called 'grotesques' from medieval times, because they had been rediscovered in cave-like chambers formed by rooms in the buried ruins of houses ('*grotte*' is Italian for 'caves'). Towards the end of the 18th century, fanciful neoclassical painted interior schemes designed by architects such as Robert Adam had become fashionable. He and the painters who worked for him drew their inspiration from classical wall painting and sculpture, but were more concerned with decorative effect than archaeological accuracy. Interest in this style intensified again in the 1860s when there was a wave of more accurate classicism based on close study of real Roman interiors, of which a few had been miraculously preserved in great detail.

As these strange and whimsical painted forms had the sanction of classical antiquity, finely detailed 'grotesques' were thought appropriate even in the most solemn contexts, such as a mayor's parlour in a northern city. These ancient playful fantasies, deriving ultimately from oriental sources, added a lively contrast to the walls of a classical building, both in antiquity and in the 19th-century revival of the style. The brilliant colours on the walls preserved at Pompeii evoked such splendour that the firm of Crace was able to persuade clients to adopt lavish schemes from the beginning until the end of the century.

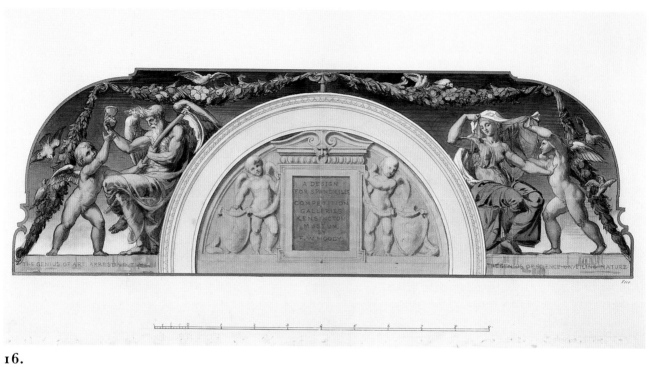

THE GENIUS OF ART ARRESTING TIME ... A DESIGN FOR SPANDRILS COMPETITION GALLERIES KENSINGTON MUSEUM BY F. W. MOODY ... THE GENIUS OF SCIENCE UNVEILING NATURE

16.

2

Early Design Reformers

As early as 1835 it was obvious to the government and British manufacturers that, although Britain led the world in technical expertise in machinery and production of goods, the standards of ornamental design were lacking in comparison with those of Britain's arch-rival, France. The French had been soundly defeated in war and their economy damaged, yet their goods still seemed to be consistently better designed. This lack of confidence in Britain was partly rooted in the fact that there was an acute shortage of artisans who could actually draw with any skill, let alone design. Unlike in France, there had been virtually no government encouragement or training in drawing and designing, apart from that given to military personnel. The Royal Academy schools were too small, and understandably biased towards the fine arts, to satisfy the demands of the manufacturers.

A Select Committee on Arts and Manufactures sat from 1835 to 1836. Money was voted and a Government School of Design was set up in Somerset House, London, to train teachers of design and help to set up other schools. By 1843 there were six other schools placed in centres of manufacturing in England. There were initial difficulties, especially as there were many vocal critics, mostly would-be reformers, each with their own plans. After conducting a sustained attack on the poor running of the design schools, the group that formed around Henry Cole was ultimately successful in seizing control of them in 1852.

Cole became Secretary to the Government Department of Practical Art in 1852 and eventually head of the Museum of

Practical Art, the ancestor of the Victoria and Albert Museum, with a brief to encourage and improve the standards of design in manufactures. The museum was built with the proceeds of the Great Exhibition of 1851, the brainchild of Prince Albert and Henry Cole. Their ideas had rapidly developed since they first met in 1846 at an exhibition of the Society of Arts, when Prince Albert was its president. Cole used and revitalized this organisation, formed in the 18th century to encourage design and manufactures, to pilot his plans for the Great Exhibition. A large profit was unexpectedly made, and spent on forming a museum and design collection which was the official centre of design reform in Britain.

16. Design for the decoration of spandrels in the competition galleries of the South Kensington Museum, by Francis Wollaston Moody (1824–86)

Pencil and watercolour 1868. 8100

Spandrels are areas or spaces on a surface formed in the construction of arches, often suitable for mural paintings or decoration. One of the characteristics of the South Kensington Schools' design tradition was the frequent use of allegorical or emblematic subjects, usually accompanied by texts or titles in Latin and, less often, English. Mural paintings, mosaics and moulded ceramic decorations throughout the South Kensington Museums bore witness to this, though much was destroyed in the 20th century when a fashion for modernist plain surfaces prevailed. There were many precedents for allegorical subjects used in the Italian Renaissance for 19th-century designers to follow, but there was also a conscious and very Victorian desire to educate the public visually.

17. Teapot, designed by Henry Cole (1808–82)

Bone china 1846. Made by Minton & Co. c.262.1-2-1993.

Henry Cole used the pseudonym Felix Summerly in 1841 when he published children's books and a series of guidebooks, and again in 1843 when he published the first Christmas card. In 1847 he launched Summerly's Art Manufactures, intended to produce objects which he thought would provide examples of good, original design. By this he meant using appropriate decoration which was seen as following the function or sentiment of the object. The ornament would not be slavish copying of past styles, but suitable for the use to which the objects would be put. He recruited various friends, including the painter Richard Redgrave, the sculptor John Bell and the painter Henry Townsend, to provide designs for his firm. Their designs are a tantalising selection of things that might have captured popular taste, but apparently did not sell in huge numbers.

Cole had been introduced to Herbert Minton, the owner of Minton & Co's pottery, by Thomas Willement, the stained-glass and tile designer. Minton was interested in improving the quality of design in Britain, willing to take risks and to experiment with the ideas of new designers. His faith in Henry Cole was rewarded when the teapot and tea service won a silver medal in a Society of Arts competition in 1846. The cups and saucers which were part of the same service were produced and sold until the 1890s, although it is not known how long the teapot remained in production. It was noticed by Prince Albert, then President of the Society of Arts, and Cole joined the society in the same year. The design of the teapot is one of the key moments in Henry Cole's career, as Cole himself acknowledged, as it was a small but significant part of the chain of events that led to the Great Exhibition of 1851.

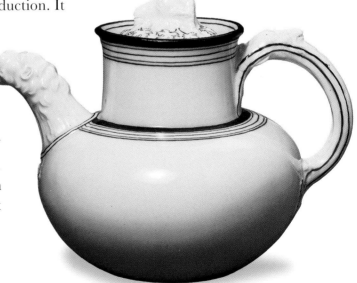

18a & b. Two designs for the 'Coach and Railway Jug', by Henry James Townsend (1810–90)

Pencil and watercolour 1855. E.5896 & A-1910

Ornament appropriate to an object's use was an essential part of Henry Cole's platform for design reform. This jug, designed by his friend (and colleague at the Government School of Design) the painter H J Townsend, was intended to contain beer. At this time most beer consumed in the home was collected in the householder's own jug from the public house or beer shop. The motifs on the two sides reflect mid-Victorian social changes as well as referring to the traditional theme of travellers seeking refreshment. On one side is the traditional coaching inn, the 'Traveller's Rest'; on the other is the new form of travel, the railway, whose passengers also required refreshment. The themes of ancient and modern are continued in the hop-vine motifs around the top, the bacchic mask which forms the lip of the jug and in a medallion beneath the lip, where the railway engine driver faces his rival, the coach driver, wrapped in his greatcoat.

The locomotive emerging from under a viaduct is probably derived from a contemporary lithograph by John Cooke Bourne. The moulded jug was a traditional form revived with some success by Summerly's Art Manufactures as well as by manufacturers, particularly Maw and Co.

19a & b. The 'Coach and Railway Jug', designed by Henry James Townsend (1810–90)

Moulded buff-coloured stoneware 1855. Made by Minton & Co for Summerly's Art Manufactures. 540-1855

The jug as executed differs significantly from the drawings, in that Townsend had envisaged it as having a traditional salt-glazed stoneware body, in two zones of colour as was often used for beer tankards and jugs. In fact it was carried out using a new buff-coloured unglazed body. Perhaps Minton decided that the form of these new-style jugs should be distanced from the traditional colours and applied moulded decoration on the old-style beer jugs made by other potteries. These latter were cheap and crude, suitable only for the public house, not for a modern, design-conscious home.

18a.

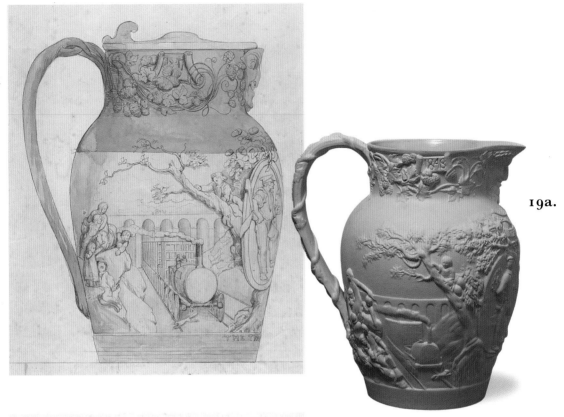

19a.

18b.

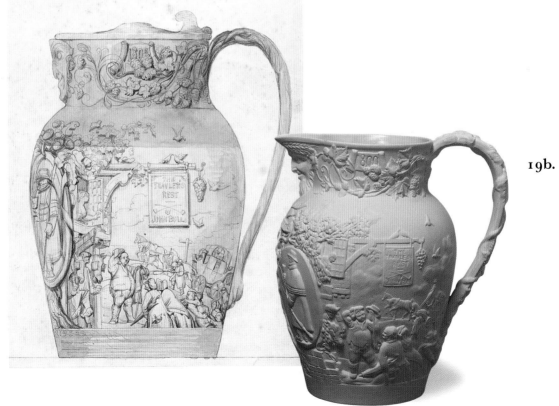

19b.

20. Details from designs for knife handles, by Richard Redgrave (1804–88)

Pencil and watercolour c1847. E.5871-1910

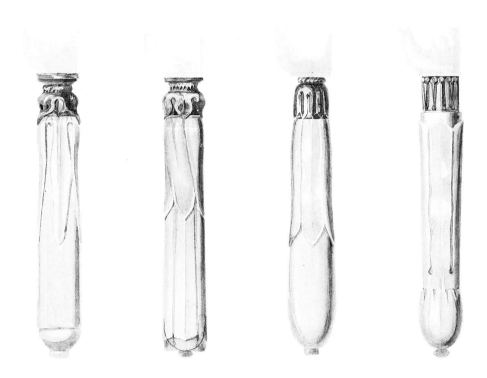

Richard Redgrave was a painter and book illustrator and one of the few contemporaries admired by the Pre-Raphaelites. He was at first a drawing teacher, then became a skilled designer and a tireless advocate for the reform of the teaching and practice of design. In 1847 he was appointed botanical lecturer at the Government School of Design at Marlborough House, which was the ancestor of London's present day Royal College of Art. He was a friend of Henry Cole and became headmaster of the school in 1848. His designs for Henry Cole's Summerly's Art Manufactures were beautifully drawn, as you would expect from such a meticulous draughtsman. These handles for knives are based on subtle organic shapes worthy of a sculptor, asymmetric but providing a good grip. They are well proportioned and would have appeared avant-garde. In some ways they look forward to the natural but stylised forms of certain Art Nouveau objects. Redgrave later wrote on the use of botanical forms in ornament as well as on the practice of design.

21. Plaque, designed by Francis Wollaston Moody (1824–86)

Earthenware with painted and lustre decoration c1870. Made by Minton & Co.

C.279-1921

Francis Moody was a designer responsible for many of the decorative schemes in London's South Kensington Museum (now the V&A) and was instructor in Decorative Art at the South Kensington School of Design (the forerunner of the Royal College of Art). Moody and his colleagues advocated the neo-Renaissance style for the decoration of secular buildings and objects – the Gothic style was more appropriate for religious purposes. This 'South Kensington style' was promoted heavily but had only limited success with the general public as consumers. This plaque, one of a series, is decorated with the head of Nero. It is based on the theme of *The Twelve Caesars*, a key classical text written by Suetonius between 98 and 138AD. It was beloved by Renaissance scholars and used by artists such as Giovanni da Majano at Hampton Court, and by many print-makers of the 16th century.

The dish itself was made by Minton & Co. Herbert Minton was a friend of Henry Cole and had already made ceramics for Summerly's Art Manufactures. Minton was interested in design reform himself and this dish, inspired by Italian Majolica dishes in the South Kensington Museum's collection, was probably made at his art pottery studio at Kensington Gore, very near the museum. In its use of lustre and the rather broad treatment of the painting, it prefigures the work of William de Morgan a few years later.

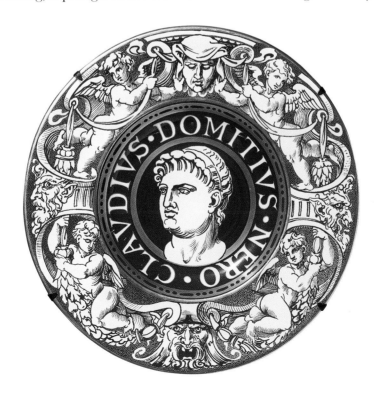

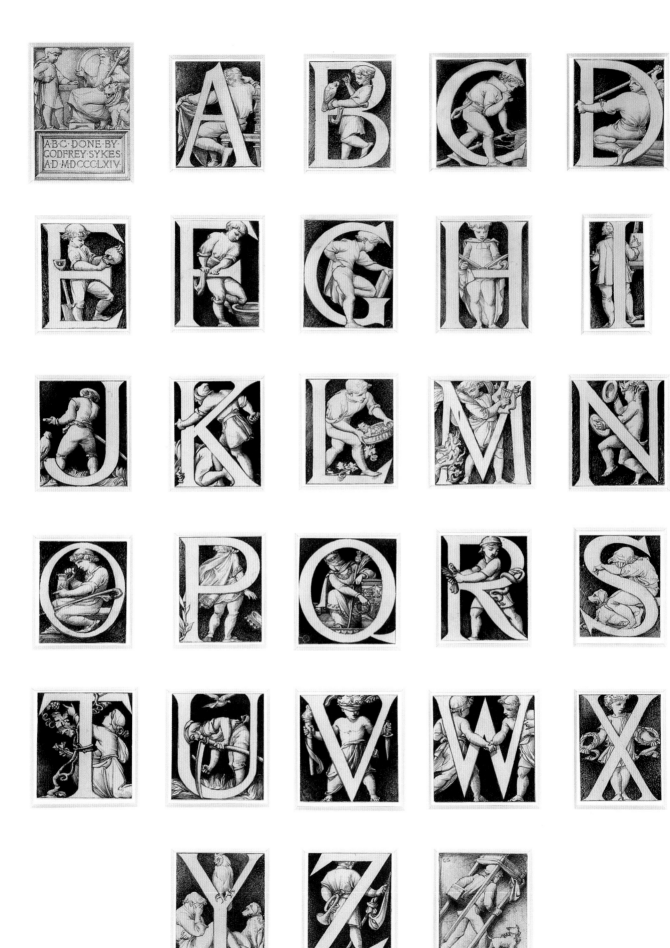

A·B·C·DONE·BY·
GODFREY·SYKES
A·D·MDCCCLXIV

22. Designs for an inhabited alphabet, by Godfrey Sykes (1824–66)

Pen and wash 1864. 729.1-28

Godfrey Sykes was originally apprenticed to an engraver and eventually entered the Sheffield School of Art. He became a pupil of the sculptor Alfred Stevens and, like his teacher, designed various decorative schemes in the manner of the Italian Renaissance. He was recruited to work for Captain Fowke on the new buildings of the South Kensington Museum in 1859 where he was responsible for much of the moulded decoration. His humorous *putti* (cherub-like figures) still decorate the columns of a former refreshment room in the building. The figures in the frieze (see below) are derived from this alphabet, produced in 1864. He seems to have made a speciality of drawing inhabited alphabets and this one, full of sly touches, was brilliantly translated into three-dimensional sculptural forms. Could it be that the first illustration, showing the artist being given his orders by the king, is actually a kind of self-portrait with the king as (King) Cole, the first Director of the South Kensington Museums and Sykes' all-powerful boss?

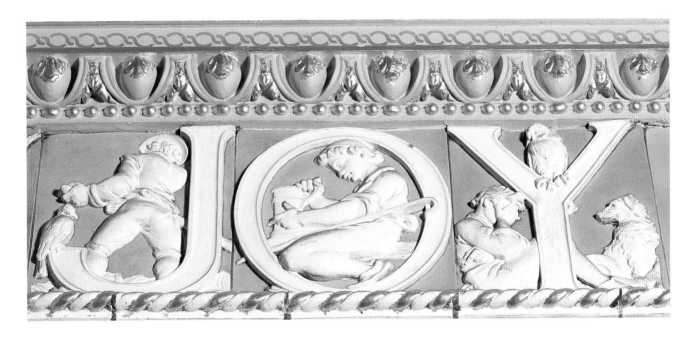

23. Detail of a frieze in a former refreshment room, now known as the Gamble Room, in the Victoria and Albert Museum, after designs by Godfrey Sykes (1824–66)

Tin glazed earthenware, 'Majolica' 1869–70. Made by Minton, Hollins & Co.

24. Sheet of sketches including designs for the chimney piece at Dorchester House, by Alfred Stevens (1817–75)

Pencil c1862. E.2532-1911

Alfred Stevens had studied for nine years in Florence, and in Rome; for a time he worked in the studio of the Danish sculptor Thorvaldson. He returned to England in 1844 and the next year was employed for a while as Assistant Master in the Government School of Design at Marlborough House. He went on to provide designs in the Italian Renaissance style for all kinds of metal manufactures – stoves, knives, cannons, railway carriages as well as decorative schemes and sculptural decoration. His work was acclaimed at the 1851 and 1862 exhibitions in London. He was given the prestigious commission of decorating Dorchester House in London. The debt to Michelangelo is obvious in the vigorous treatment of the crouching caryatids who support the massive fireplace. The lively sketch illustrated here was then used as a guide to an elaborate full-scale plaster version now also in the V&A's collection. In the initial stages of most of his projects, in conscious emulation of the old masters, Stevens continually put down his ideas in rapid sketches. They were much admired by his contemporaries, but all too few were actually realised.

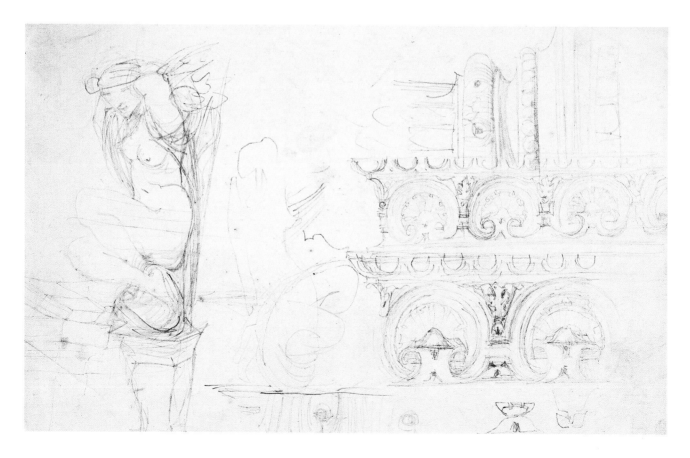

25. Chimney piece from Dorchester House (now in the V&A), by Alfred Stevens (1817–75)

Marble 1863–75. A.2-1976

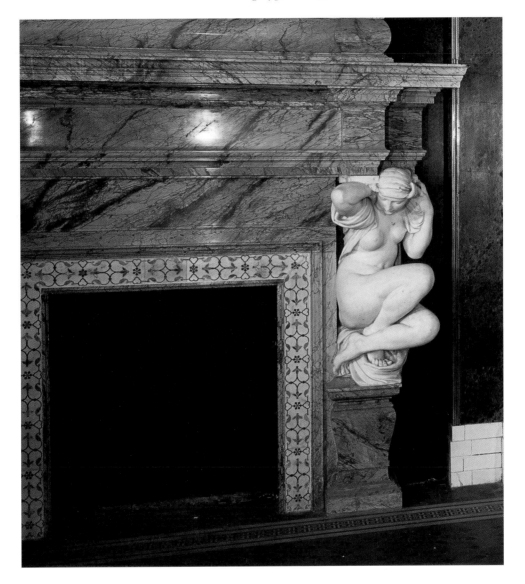

The final version of the chimney piece in marble was installed unfinished in Dorchester House in about 1869. Stevens failed to finish the carving, and it was completed by his assistant James Gamble. Some of the life and vigour visible in the plaster model has evaporated, though it is still an impressive object. Stevens was slow to carry out his commissions and his vast monument to the Duke of Wellington in Westminster Abbey was completed after his death. Even so, he profoundly influenced his contemporaries, his devotion to the dramatic treatment of the human figure led to the 'new sculpture' in Britain in the late 19th century.

26. Design for the interior of the Museum of Practical Geology, Jermyn Street, by Alfred Stevens (1817–75)

Pencil and watercolour c1847. E.2114-1911

The historical style that Henry Cole and the Government School of Design put at the top of their design hierarchy was that of the Italian Renaissance. Their design hero was Michelangelo, and they had great hopes that eventually a school of British sculptors and architects would emerge whose students could emulate his achievement. Alfred Stevens seemed at the time to be the most promising candidate, as he was an architect and sculptor who could design in many media. He had consciously modelled his style on Michelangelo and other Italian masters, imitating their habit of making free and rapid sketches which would finally result in the most detailed and elaborate decorative schemes or sculpture.

Although Stevens' work set the style for the early buildings on the South Kensington Museum site, a disagreement with Henry Cole over the methods of design teaching meant that he did not actually design any of the museum's structure. His particular highly decorated Italian Renaissance style was not generally adopted in Britain. Only certain well funded buildings, such as those usually associated with museums, education and the schools of design were constructed in this expensive manner. To counter the corrosive effects of London smoke, experiments were made with the use of terracotta mouldings on the exterior, always inspired by north Italian Renaissance examples.

One such project was the Museum of Practical Geology in Jermyn Street, a very Victorian concept consciously mingling art, science and commerce. It contained examples of industrial and artistic products which were made from raw materials mined from the earth. Gemstones, clay, slate, marble and every kind of building stone, cement and hundreds of other ingredients were displayed in their finished state to encourage research and manufactures. Objects as disparate as bricks and Sèvres vases were collected and displayed. After 1909 the Jermyn Street museum was run down and the incredibly varied collections split up and divided between the Victoria and Albert Museum, the Science Museum and the Geological Museum in South Kensington.

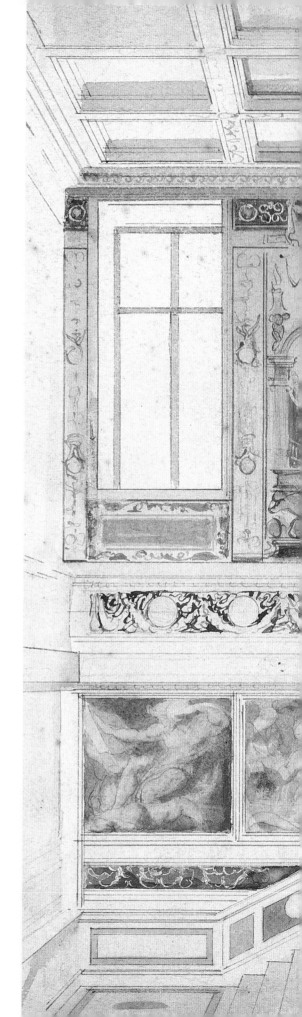

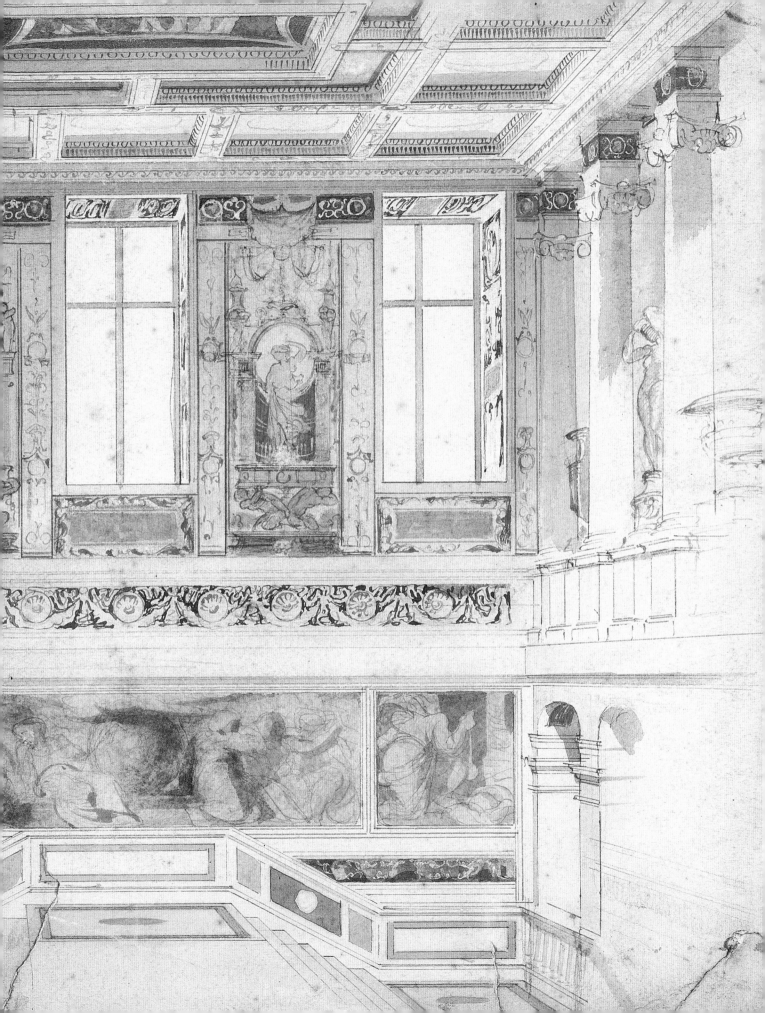

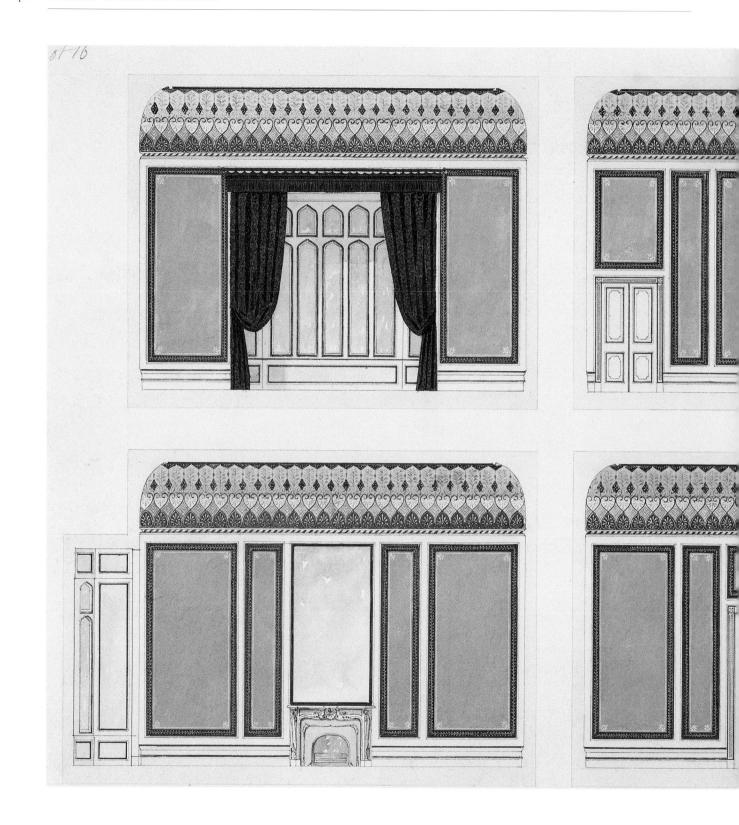

27. Two designs for the decoration of a music room, by Owen Jones (1809–74)

Pen and ink and body colour 1850s. E.1689 & 1698-1912

Owen Jones had been brought up in Regency England at the height of the neoclassical revival, in which fashionable architecture was still carried out in uniformly white stucco or stone. Expeditions made to Turkey and Egypt when he was still training to be an architect had convinced him of the merit and vigour not only of non-European forms of architecture, but also of the application of strong clear colour and polychrome decoration on both the interiors and exteriors of buildings. He studied various scientific and theoretical treatises on colour including those of Goethe and Michel Eugene Chevreul. Jones employed his colour theories on structures large and small, ranging from the vast exhibition courts at the Crystal Palace in Sydenham, south London, to domestic settings like those shown here, in which the existing subdued classical architecture was given dense colour treatments.

28.

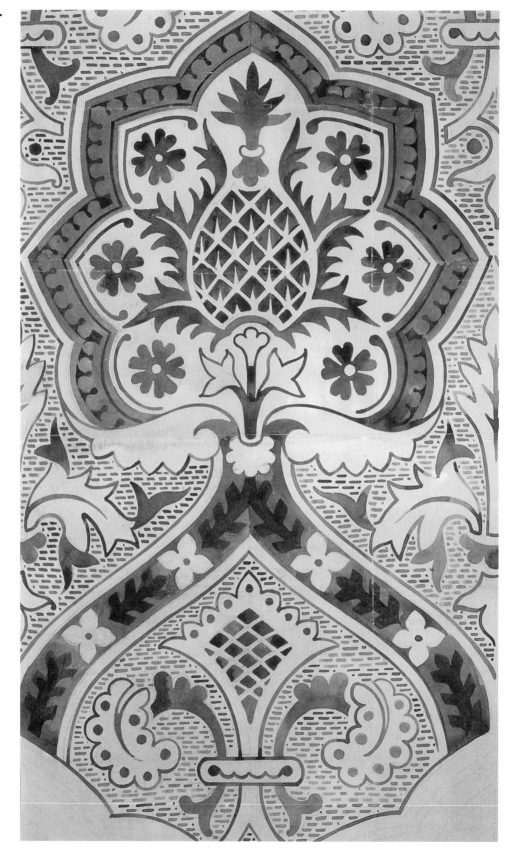

3

Reformed Gothic

A FEW ELEMENTS of Gothic architecture had survived and were being practised into the 18th century. Since the Middle Ages, architects had from time to time repaired or restored medieval churches and other buildings with new work that matched the old. From the 1740s a number of houses, monuments and follies were made or decorated using features copied or inspired by Gothic structures. Horace Walpole's 18th-century house, Strawberry Hill, contained decoration that had been carefully copied from historic examples. A love of the picturesque past was the dominant force underlying Walpole's interest in the style, rather than a wish to recreate a medieval Christian ethos.

The need to provide new churches for a rapidly expanding population in urban areas in the early 19th century, combined with religious revivals, made the question of an appropriate modern style for Church building of consuming interest. Many towns and cities in Britain had mushroomed as a result of the Industrial Revolution. They appeared raw and new, their neo-classical chapels and factory chimneys utterly unlike the dreaming spires and half-timbered houses of ancient towns. In reaction to this, many desired to revive traditional Gothic architecture and so soften the townscape. There were inevitably disputes as to how medieval forms should be imitated in the construction of the urgently needed new churches. However, the valuable lessons already learnt by architects in surveying and repairing Gothic buildings enabled them to enlarge the repertoire of designs.

The figure who emerged as the champion of a revived and reformed serious Gothic style was Pugin.

It is difficult to summarise the huge achievement of Augustus Welby Northmore Pugin. He is known best as the decorator of the Palace of Westminster, and so he was already recognised before Victoria came to the throne. His main effect was on his contemporaries and the next generation who listened to his passionate advocacy of a Gothic style. He urged this with the powerful conviction of a believer and a Catholic convert, believing that the classical styles were immoral or tended to encourage a secular and sceptical attitude.

It could be argued that Pugin's attempt to re-establish the Middle Ages was doomed from the start. As he recognised himself, it was necessary for the designer to be animated by belief. Without that passionate feeling, the psychic fuel would be absent, and certainly in the worldly and secular 20th century, that particular power and conviction was not generally present in architecture or decorative arts.

Pugin was the single most important figure in Victorian design. Unlike many enthusiasts, he was capable of drawing, making and building in the way he advocated, and he mesmerized a whole generation of architects and designers who passionately believed in the aesthetic supremacy of the Middle Ages. They were directly influenced by his writings and his work. They also keenly admired medieval craftsmanship and the best wished to forge a modern, living style, not slavish copying but new work based on real examples from an ancient tradition.

His advocacy of 'truth to materials' and honesty in showing the structure of his furniture also influenced the Arts and Crafts movement later in the century. These two theories were even adopted by the modern movement in the 20th century, though the particular forms of Gothic decoration Pugin advocated had by then been long abandoned.

28. Detail of full-size design for a wallpaper for the Palace of Westminster, by Augustus Welby Northmore Pugin (1812–52)

Pencil and watercolour 1848. D.756-1908

Pugin had studied examples of medieval woven silk textiles preserved in the cathedral treasuries of France and often represented in the backgrounds of late Gothic painting. His acute visual memory and his numerous rapid sketches of interesting examples of these and other patterns in different media meant that he could draw on a large repertoire of authentic details for his patterns. Wallpaper had been introduced to Europe only in the 16th century, so it had no medieval precedent. Pattern decoration on medieval walls in churches and castles had either been painted directly in brilliant colour onto the surface, or textiles such as tapestries, woven silks or painted canvas had been used.

Opportunities to revive this practice in Britain were limited, and it never became fashionable for the decoration of most houses. Pugin therefore found himself applying Gothic ornament to what was actually a substitute for costly and (especially in the British climate) technically difficult wall painting, or even more expensive woven textiles.

29. Drawing of an armoire or oak cabinet with brass panels, by H Michael (worked mid-19th century)

Pencil and watercolour 1851. Drawing made from designs by A W N Pugin, reproduced in Industrial Arts of the XIX Century, at the Great Exhibition 1851 *(1853) by Matthew Digby Wyatt.* D.1050-1886

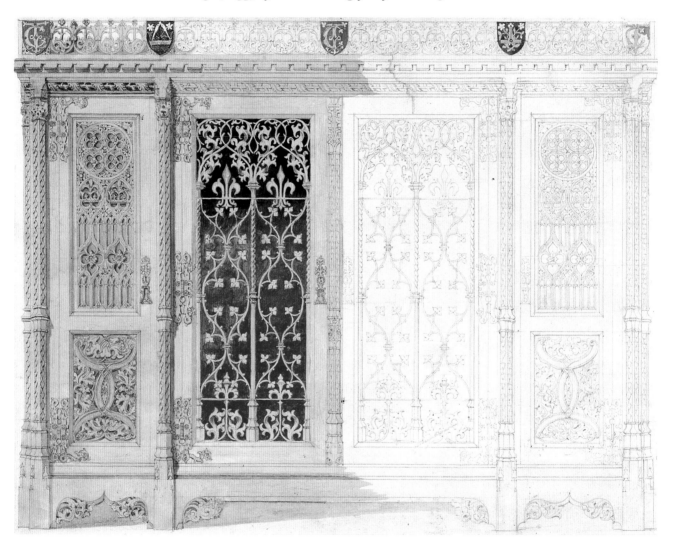

This drawing of the large cabinet intended for the Palace of Westminster was reproduced in the catalogue of the Great Exhibition of 1851. Pugin had arranged the medieval court in the exhibition and, unlike other sections, this court was displayed by style and not grouped by product or by manufacturer. It is not known who H Michael was, but it is probable that he based his illustration on one of Pugin's designs, as he highlights some of the constructional details of the front elevation. The illustration was reproduced in the catalogue as a high-quality colour lithograph, which helped to promote Pugin's idea of noble Gothic furniture.

30. Carved oak armoire, designed by Augustus Welby Northmore Pugin (1812–52)

Made by J C Crace 1851. 25-1-1852

This object was much admired and probably would have won a prize medal in the Great Exhibition. Unfortunately for J C Crace, who was on the judging committee, his firm had made the armoire and thus he was not able to vote for his own work. However, he was gratified to find that the Museum of Ornamental Art, the forerunner of the V&A, bought it for the museum's collection in 1852 for the large sum (at 1852 prices) of £154 – three years' wages for a working man. As an indicator of the sinking esteem in which Victorian art and design was held in the 20th century after 1914, the museum actually contemplated disposing of this cabinet in 1933. Fortunately it was reprieved as it proved useful as a bookcase at Bethnal Green Museum, where it stayed until its inclusion in the exhibition of Victorian and Edwardian Decorative Arts at the V&A in 1952.

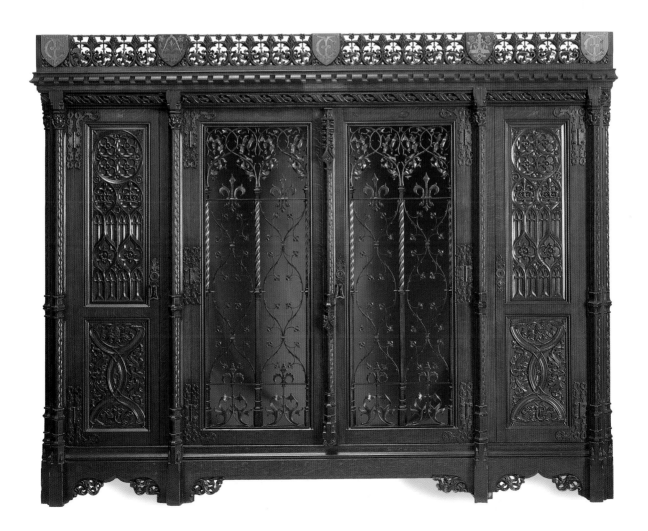

31. Design for a decanter, by William Burges (1827–81)

Pencil and watercolour. 8830.3

32. Chinese *sang-de-boeuf* flask, with mounts designed by William Burges (1827–81)

Chinese 18th-century vase. Silver gilt mounts decorated with semi-precious stones 1870. Maker unknown. M.22-1972

The architect William Burges was an antiquary and an avid collector of rare and precious things. He not only appreciated the old and beautiful remnants of antiquity but successfully incorporated them into his work. His designs for such things as this mounted piece of Chinese porcelain used semi-precious stones, antique gems, ancient gold coins, Chinese jade and fragments of jewellery in an exquisite new assemblage. Burges was able to design on all scales; his achievements include a complete new castle in the Gothic style at Castle Coch in South Wales, splendid pieces of furniture and tiny jewelled cups.

Although he had studied medieval designs intensely, he was confident enough to depart from his exemplars and create completely new objects that had no direct precedent. They convince because he seems to have entered into the spirit of the medieval age and took the same delight in making precious things as the Gothic craftsmen had done. This design for a decanter is one of a series that he designed, often for his own pleasure and use.

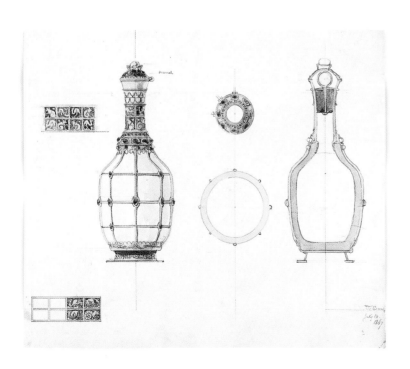

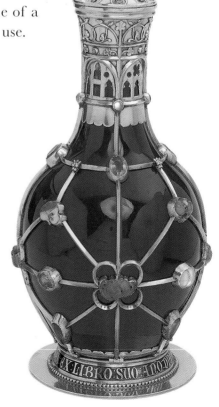

33. The Yatman Cabinet, by William Burges (1827–81)

Oak with painted panels 1858. CIRC. 217-1961

Burges was the first designer in Britain to revive the idea of painted furniture, even before William Morris and Burne-Jones. A whole series of cabinets were made, based in part on medieval prototypes but infused with impish touches of humour. Although designed by an antiquarian, they are full of colour and life, contradicting the dusty image of antiquarian attitudes. Burges had seen in France the only two surviving pieces of elaborate French 13th-century furniture and had sketched one of them at Noyon as early as 1853. Both were illustrated by the French architect Viollet-le-Duc in 1858, whose books influenced Burges and a whole generation of Gothic architects in France and Britain.

H G Yatman had commissioned this cabinet from Burges, inspired by the example at Noyon. Burges' friend, Edward Poynter, painted the cabinet with classical and medieval scenes. Portraits of Burges and Poynter himself were also depicted in roundels. The roof of the cabinet was made of sheet metal, painted to a recipe that Burges had found in a book by Theophilus, a medieval monk. The cabinet was borrowed back from Yatman to be shown at the 1862 exhibition in London. It attracted a generally enthusiastic response, unlike the painted cabinets on the Morris, Marshall Faulkner and Co stand which received mixed and sometimes hostile reviews.

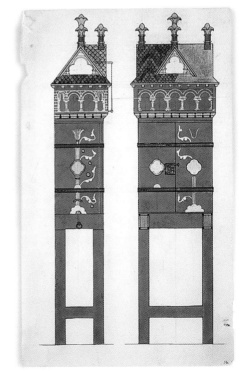

34. Designs for a painted cabinet, by William Burges (1827–81)

Pencil, water- and body colour c1860. 8829.5

35. *(overleaf)* Designs for a painted cabinet, by William Burges (1827–81)

Pencil, water- and body colour 1858. 8829.1

2.

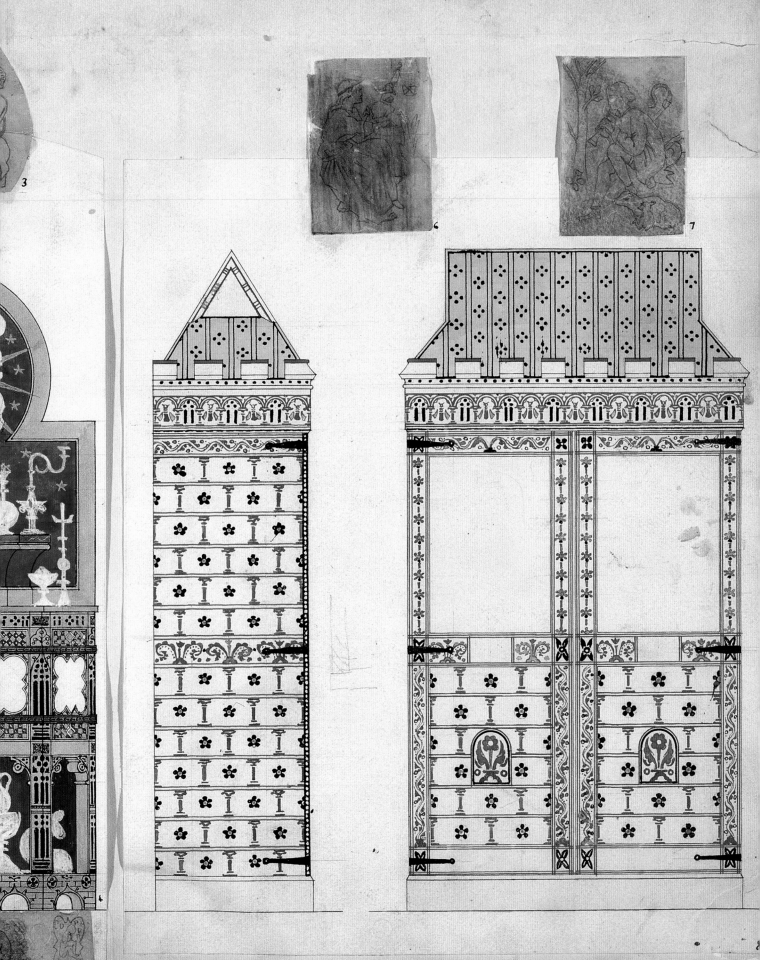

36. Design for a wardrobe, by John Pollard Seddon (1827–1906)

Pencil and watercolour c1860. D.1787-1896

Seddon, an architect like Burges, designed Gothic furniture but he was closer in spirit to Pugin, particularly in the serious way he respected 'truth to materials'. The simple lines and traditional methods of construction, using pegged joints and exposed structures, influenced the next generation of architects and designers who formed what is now called the Arts and Crafts movement. This style was particularly appropriate for churches and vicarages, but the plain practicality and solidity of his furniture was employed in secular domestic contexts as well. The simplicity of his work was such that it is difficult now to distinguish his furniture from that of his later imitators.

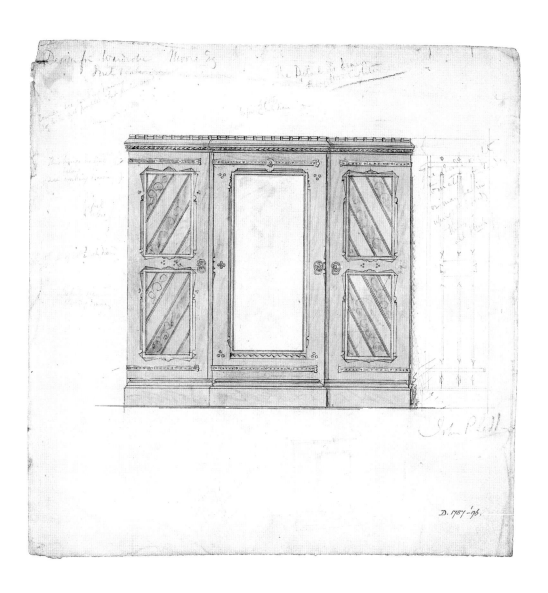

37. King René's Honeymoon Cabinet, designed by
John Pollard Seddon (1827–1906)

Oak, inlaid with various woods, with painted panels 1860. W.10-1927

The architect Seddon also designed elaborate pieces of furniture as occasion demanded. His father, cabinet-maker Thomas Seddon, made an inlaid and chamfered roll-top desk to his son's Gothic design which was shown at the 1862 exhibition on the William Morris firm's stand. The famous 'King René's Honeymoon Cabinet', designed in a similar style with painted panels by William Morris, Edward Burne-Jones, Dante Gabriel Rossetti and Ford Madox Brown, was exhibited on the same stand. Seddon designed this 'Architect's desk' (as it was then described) for his own use and commissioned Morris' firm to undertake the painting. It takes its present name from the imaginary scenes of the life of King René of Anjou depicted in its panels. Like many other Victorian works of art, it took its imagery from a novel by Sir Walter Scott, in this case *Anne of Geierstein* (Edinburgh 1829). The medieval King René was idealised as a patron of the arts and was believed to be a painter himself.

Seddon stayed faithful to the Gothic style to the end of his life, and as late as 1906 designed an utterly enormous Gothic Imperial Monumental Halls and Tower for Westminster which, had it been built, would have dwarfed Westminster Abbey.

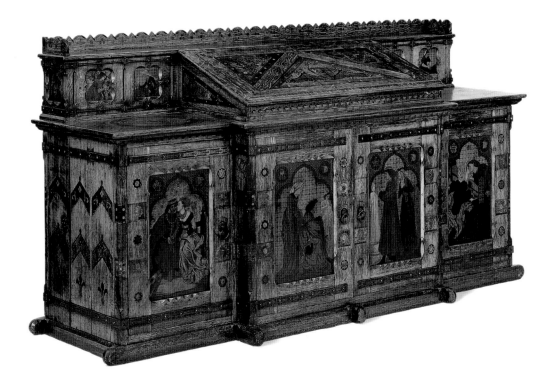

38. Design for a cradle, with a diagram showing the construction of the rocking device, by Richard Norman Shaw (1831–1912)

Pen and ink 1861. Given by Michael Waterhouse CBE MC PPRIBA E.75-1961

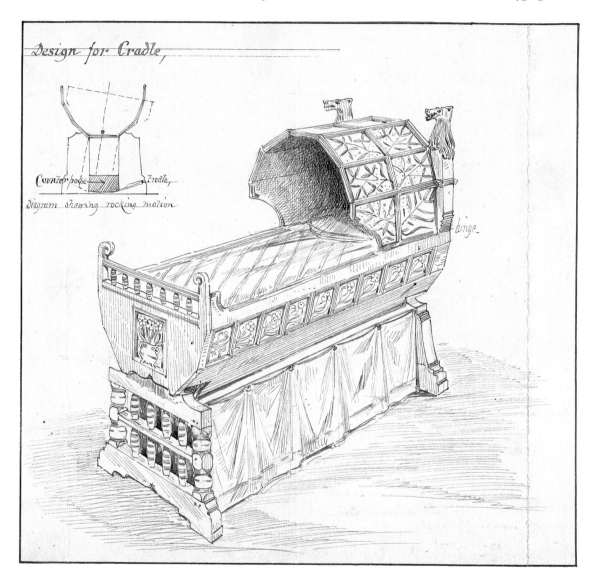

At this date Shaw was designing in the reformed Gothic style associated with William Burges and William Morris, in which painted panels were the chief decoration. Very similar painted panels, but without Gothic framing, later became popular for both Aesthetic movement and Arts and Crafts furniture. Although the structure of the cradle is close to the design, the painting of the panels differs, as the floral patterns in the drawing are replaced by signs of the zodiac on the finished piece. Shaw is best known for his architectural work in which he combined Japanese detailing with the romance of 'Old English' vernacular red-brick and timbered buildings.

39. Oak cradle, designed by Richard Norman Shaw (1831–1912)

Painted and gilded, with leather straps 1861. Maker unknown. CIRC 847-1956

Shaw designed this Gothic cradle, decorated with panels showing the signs of the zodiac, for the son of the architect Alfred Waterhouse. The inclusion of an 1861 farthing coin in the hood as a good luck charm indicates the date. The design for the cradle shows curtains enclosing the open sides. The hood is hinged and designed to tip back, restrained by leather straps, to give access to the baby. The extremely heavy pieces of oak used in its construction would not be regarded as safe for today's non-Gothic babies.

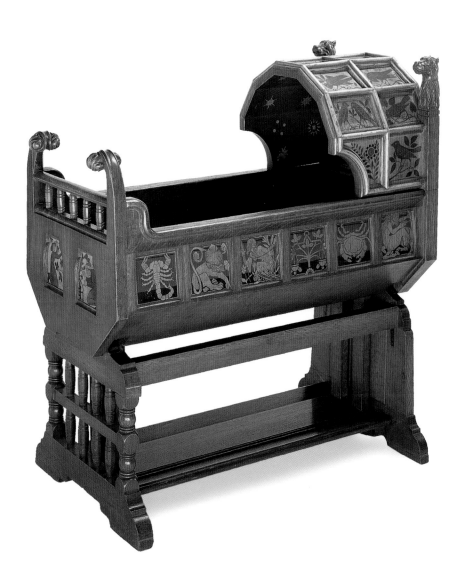

40. Record drawing of the Royal Throne in the House of Lords, designed by the firm of Holland and Sons, and King Edward VII (1841–1910)

Pencil and watercolour on card 1901. Intended for use as the basis of a design for the throne for Queen Alexandra. Given by Mrs A Norman. E.6-1985

Amateur designers were able to have their designs made up if they were wealthy or influential enough. An unexpected example of this is a design which is partly by the amateur (in design terms) King Edward VII. It comes within the scope of this book because the original designer was Pugin, who designed the throne for the Palace of Westminster for Queen Victoria. The King wanted an extra throne for his consort, Queen Alexandra, so he ordered that a drawing should be made of Pugin's work, and then specified (as his inscription says) a smaller version of the throne to be made, with minor changes of detail. Edward was particularly involved in the preparations for his own coronation and made precise specifications as to how the event should take place. He had waited a long time to become King, as his mother had reigned for 63 years. He was autocratic and sophisticated enough to have had thrones made in any style that he wished, but he wanted his accession to be hallowed by traditional forms, even if they had been reinvented by Pugin only 65 years before. Obvious modernity would not have been appropriate.

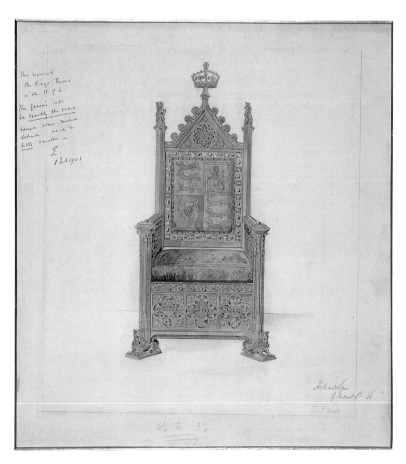

41. Design for an elaborate crozier, by George P D Saul (worked late 19th century)

Pen and ink and watercolour 1889–90. E.720-1993

The Gothic style persists to this day in designs made for traditionally minded members of the church, but for domestic use it had almost died out by the end of the Victorian period. This drawing, although made for an ecclesiastical context, has been included to illustrate some of the reasons for its decline in popularity. A rather hard and dry, literal copying style developed by the 1890s, showing a relatively unimaginative use of medieval prototypes. Some art historians call it the 'Latest Gothic'. In this drawing the figures are based on a celebrated set of medieval silver figures, now in the V&A, which have often been used to make fake apostle spoons. The reasons for the decline in the energy of the reformed Gothic movement are complex, but the decay in the once-fashionable belief that only the late medieval forms of Christian art (as championed by Pugin) were the best must be partly to blame. Another factor was the advance of scientific materialism, particularly among intellectuals.

4

Mainstream Victorian

WHILE THE DESIGN reformers were struggling to improve the taste of the nation, most of the population carried on with what commercial manufacturers provided for them, both producer and consumer being subject to the whims of fashion. Comfort was the only theme that bridged all the different kinds and mixtures of design choices people could make for their homes. Improvements in technology meant that cheaper machine-made carpets, upholstery, furniture and ceramics were available to a much greater number of people than ever before. They were decorated and formed in a rich mixture of styles, which modern design historians now term 'eclectic', as the manufacturers and their designers chose what they pleased from all the historic styles they imagined would appeal to the public.

42. Design for a carved and painted wooden waste-paper basket, by Lorenza Booth (worked mid-19th century)

Pen and ink and watercolour 1864. Given by Alec Tiranti. E.4727-1960

So much is destroyed by neglect and the passage of time. Relatively humble objects survive only if they are durable and useful. A waste-paper basket is undeniably useful, but an ornamental structure such as this would eventually succumb to hard use and changes in fashion. If this drawing of a waste-paper 'stand' had not been saved, then the only evidence of the design work of Lorenza Booth (about whom nothing else is known) would have perished too. This design is inscribed, yet the curator who in 1960 acquired it mis-read the name of the designer as 'Lorenzo'. The assumption was that it must have been a male designer, as indeed the majority of recorded designers in the 19th century were. There were thousands of other designers, particularly in textile and other pattern-demanding trades, who are completely unrecorded. The presumption is that a large proportion were women.

This is an example of high Victorian Gothic with naturalistic foliage. It is completely unarchaeological, but the delicate pinnacles which form the frame have the quality of the Gothic revival of the earlier part of the century.

43. View of a drawing-room, painted by Samuel A Rayner (worked c1821–72)

Watercolour c1855. Henry Herbert Harrod bequest. E.1167-1948

This drawing-room in a wealthy London house is decorated and furnished in the style set by the court of Napoleon III in the 1830s and 1840s. It dominated luxury decoration and furnishing in Europe and America in the 1850s and remained popular until the end of the 19th century. Derived from the

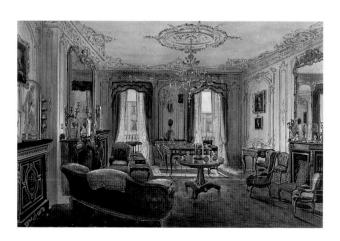

French Rococo style of the mid-18th century, the walls are panelled in gold and white. The air of rich comfort and relative informality, however, is entirely mid-19th century. It was this style which became a particular anathema to William Morris and other design reformers, but its consumers remained in the majority.

Samuel Rayner was an architectural painter and lithographer who specialised in interiors.

44. Vase, by Minton & Co

Porcelain, painted in colours c1857. 4325-1857

This Rococo-style vase is a British copy of one produced in the 1730s by the Sèvres porcelain factory. It was purchased by the South Kensington Museum in 1857 for the considerable sum (at 1857 prices) of £18.18.0 (18 guineas) as an example of modern manufacture. French luxury objects of this kind were much admired and collected then, as they are now. The museum was prepared to buy copies of French work as examples of what an enlightened manufacturer could produce. The delicate painting, the complex form of the body and its historic associations made it admirable in the eyes of the Victorians.

This kind of Rococo style was particularly offensive to William Morris. In his writings he condemned it as part of that 'exultant rascality that went down to the pit forever', but he was wrong if he believed it would finally disappear.

45. Design for a milk jug, by Hunt & Roskell

Pen and ink c1845. E.5026-1960

This design for a silver milk jug (actually inscribed 'milk pot' on the design) is a rare survival of a mid-19th-century silver design for a relatively modest domestic vessel. The mixture of styles is typical of the medium and period. The handle is a Rococo scroll form, though somewhat less graceful than those of the previous century, and the spout is based on a mask form of the 17th century. The decoration is rather poorly drawn, but would appear better-looking when engraved or chased on the finished vessel. The subject is not particularly appropriate to its use, as design reformers such as Henry Cole would have preferred. Similar scenes of hunting are found engraved more appropriately on expensive sporting guns, but enthusiasts for the chase, and there were many in Victorian times, carried over their favourite motifs to all kinds of other domestic objects. Similar images of hunting dogs and birds are found painted on ceramics and engraved on glass.

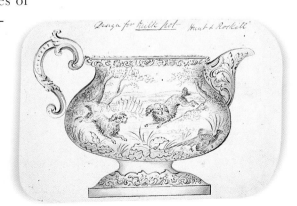

46. View of a room at Christ Church College, Oxford, attributed to George Pyne (1800 or 1801–84)

Watercolour c1855. Henry Herbert Harrod bequest. E.3253-1948.

This is one of a group of drawings which carefully record the rooms of wealthy students in Canterbury Quadrangle, Christ Church College, Oxford. The furnishings, including the fitted carpet, softly upholstered neo-Rococo chairs (with interior springs), large centre table and piano epitomise the mid-Victorian ideal of the comfortable living-room or parlour. The plain walls with their floral wallpaper borders (matching the chair-covers, curtains and carpet), together with the array of fashionable watercolours, point to an occupant (and decorator) both tasteful and artistic. At night the centre of activity would have been the large table, upon which the two lamps at the side would have been placed. The print hanging above the mantelpiece appears to show Wellington meeting Marshal Blücher on the field of Waterloo.

This picture exemplifies some of the problems of discussing Victorian design. How typical is this room setting? The wealthy young man at a smart Oxford college would develop his taste there; one of the things that seems to have been fashionable is the otherwise unusual practice of commissioning an artist to record your room. The paintings had a specific appeal as souvenirs, as most of the students were there for only a brief period. This time of freedom would never come again as they were expected to marry and leave the follies of youth behind them upon entering the world and taking up its duties according to their station.

Such careful record pictures of interiors are uncommon and when they do appear it is often difficult to know whether they represented a minority or a majority taste. As the students at Oxford formed such a tiny proportion of the population, it would seem that it was a minority taste. Yet the students often became influential in many walks of life and therefore many developed into style leaders as they matured. In some ways these watercolours are better than early photographs as they are in colour, and are much more atmospheric than the dark impression given by black and white images.

47. Design for a carpet, from an album by George W Kingman (worked last quarter of the 19th century)

Pencil and body colour c1875. E.554.1-105-1956

Textiles are particularly vulnerable to damage and British machine-made carpets of the 19th century have almost completely disappeared. Designs for carpets are much rarer than those for printed cottons and other textiles, and this album of designs by Kingman for a firm from Kidderminster, near Birmingham, is a particularly valuable source for what they must have looked like. Most of the designs in this album have a darker ground than the one shown. Dark colours were a sensible decision considering the filth of the streets and the soot and smoke from the coal fires used everywhere for heating and cooking. A light-coloured carpet could have been put down only in special locations, and protective covers of plain, coarse-woven cloth called 'druggets', similar to those used for expensive upholstered furniture, would have been used in certain cases. Some watercolours of interiors show similar carpets, but it is not easy to be certain what most carpets looked like at a specific date, and how quickly fashions changed.

48. Design for a ceiling in the Rococo style, studio of
John Gregory Crace (1809–89)

Pencil 1842. E.829-1981

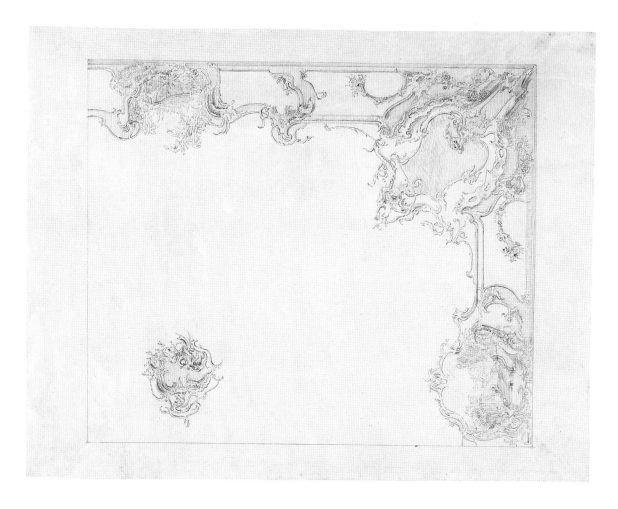

This Rococo scheme for a ceiling is a modified tracing from an engraved pattern book by J F Cuvilliés (1695–1768), first published in 1738. The light and airy patterns of the Rococo style, introduced to Britain from France in about 1735, had a relatively brief period of high fashion in interior decoration. It persisted longer in smaller objects like ceramics, although it was never universally popular in Britain and did not find favour for the exteriors of buildings in the 18th century. Many objects survived, however. They might contrast sharply with the more severe lines of the neoclassical ornament that eventually replaced them, but many Rococo objects, especially the small and charming ceramic figures, were preserved for sentimental reasons. Also, expensive pieces of furniture tend to be kept, and one of the indicators of a long family history was a grand room filled with a mix of things of different ages.

To many people in the 1840s the Rococo style suggested grandeur and opulence and seemed essentially French, the French being perceived at the time as European leaders in style. It had added resonance because it represented the France of the pre-Revolutionary nobility, and so had a historic dimension which further sanctified it. The serious revival of interest was signalled by the Rococo pattern-books republished in the 1830s and the many rooms decorated as conscious recreations of the style. By the 1850s Rococo was the basis of standard furnishing and decoration.

The Crace family formed a firm of very successful 19th-century decorators, descended from a Crace who was an 18th-century coach-painter. They decorated and redecorated many large houses and even palaces, including the Brighton Pavilion, in whatever style their clients preferred, including Gothic, Pompeian, Elizabethan and neoclassical.

49. Design for a boudoir ceiling in the Rococo style, by George Edward Fox (1833–1908)

Pen and ink and watercolour c1870. Given by Mill Stephenson FSA. E.79-1919

George Edward Fox was a successful and adaptable interior designer with a large number of wealthy clients. He worked with the firm of Crace and specialised in lavish versions of historic French styles. This boudoir ceiling was designed for Lady Wimborne, and the prettiness of the revived Rococo style was considered particularly suitable for the private rooms of a fashionable woman. The splendours of house interiors that had belonged to members of the French court of the 18th century had reached an almost mythological status by the 1870s. They were much imitated, to the displeasure of design reformers in Britain. Fox's drawings were not collected by the V&A until 1919, after there had been yet another revival of 18th-century styles in interior decoration in the first two decades of the 20th century. The highly skilful watercolour techniques used in making attractive presentation drawings for his clients probably persuaded the museum to accept them into its collections. Fox had exhibited his designs at the Royal Academy in the 1870s.

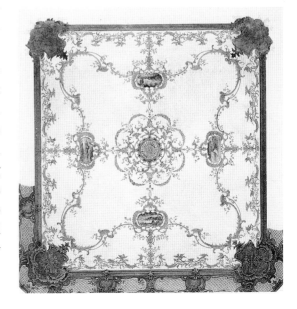

50. Design for a gold locket, set with diamonds, to contain a photograph, by the firm of John Brogden (1864–84)

Pencil and watercolour c1870. E.2.1345-1986

About £65 –
opening for one
photograph

Jewellery represented in miniature the eclectic ideas of the Victorians. Historic jewellery was much imitated; actual surviving medieval and Renaissance pieces were copied as well as those depicted in paintings and recorded in engraved ornament. John Brogden employed a number of designers and could produce pieces in any style that was wanted; he also developed new styles of his own. The V&A has a large number of his highly finished drawings similar to the one shown here, which acted as designs, records of pieces made and as presentation drawings to entice new customers who might want something from stock or a variant on it. This locket design is a typically Victorian practical combination of old and new ideas. It is something like the precious metal cases for miniatures, usually containing portraits of loved ones, a form of sentimental jewellery that had been sporadically popular in Britain since Tudor times. There was a revival of the fashion in Britain in the early 1870s. However, instead of the miniature painting normally hidden inside, there was an opportunity for new technology. A photographic portrait, perhaps hand-coloured, was substituted for the art of the miniature painter.

51. Design for municipal sunken gardens, by William Miller (1828–1909)

Pen and ink and watercolour c1900. E.810-1979

William Miller started at the very bottom as a gardener's boy, rather like Joseph Paxton, the designer of the Crystal Palace. He worked his way up and eventually became an important designer of large parks and gardens. He had studied garden history and was perfectly aware of the latest technology in horticulture, but he knew the public's preference for tradition. He wrote in an article in the 'Gardeners' Chronicle' that as a youth he had been taught the serpentine line of beauty, popularised by William Hogarth's treatise published in 1753.

Miller's approach to his lay-out was that of a decorative pattern-maker, rather than that of someone working in three dimensions. He did not adopt

the wild 17th-century fantasies of Isaac de Caus, nor the severe geometry
and elegance of the French gardens of the same period, still less reflect any
of the 18th-century British essays in the picturesque. As Miller's designs
were often for public 'lounges' as they were then called, they had to appeal
to the widest possible popular taste. The 18th-century desire for a subtle
and artful arrangement of a landscape, to achieve apparent naturalness and
informality, had given way in the late 19th century to a desire for an openly
contrived artificiality. It was a kind of pattern-making imposed on park land,
now enclosed by the sprawling brick structures of an industrial town.

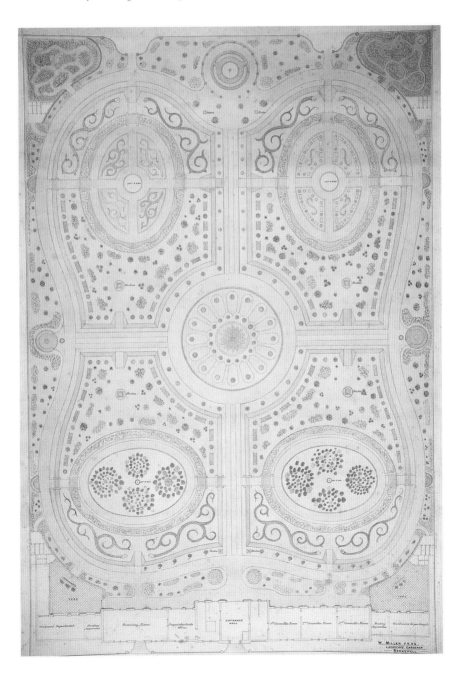

52. Three designs for firedogs and fire baskets, by George Edward Fox (1833–1908)

Pen and ink and watercolour c1855. Given by Mill Stephenson FSA E.111-3-1919

George Edward Fox was an architect who produced designs for all kinds of interior fittings, and these fire baskets are typical of the elaborate metalwork wrought by the great iron and steel manufacturers. Revolutionary methods of producing and forging new forms of metal were being developed in the 1850s and 1860s, and the latter half of the century is now regarded by some historians as the 'age of steel'. For a middling household it meant that the cost of such things as iron grates, mantelpieces and stoves was progressively reduced. The hearth was literally and figuratively the focus of the Victorian home, and the chimney piece and all its accoutrements were a place for display. The highly decorated design shown here was probably intended for one of the main rooms of the house, perhaps the drawing-room. The tall andirons or firedogs which support the grate are based on engraved ornament patterns of the 16th century, appropriate for a Tudor-style house or interior. The others, much less elaborate and decorated, were for bedrooms.

53. Detail of design for the decoration of a ceramic water jug, of vine leaves and stems, by Frederick Alfred Rhead (1856–1933)

Pen and green ink and wash c1900. E.293-1987

Rhead provided a large number of designs for various potteries. Many of his surviving drawings, now in the V&A collection, are humorous designs for brightly coloured mass-produced ceramics which reflected the popular late 19th-century demand for rather feeble (to modern tastes) comic drawings. However, here is a design which could have been produced at any time during the Victorian period: large inoffensive naturalistic sprays of vine leaves and stems suitable for a washstand jug. Only the distinctive shape of the vessel itself enables a rough date to be assigned to this object.

54. Design for a ewer, decorated with grotesque ornament, by Léon Victor Solon (1872–1957)

Pen and ink and watercolour, with touches of gold paint c1895. E.777-1978

L V Solon was the son of the more famous Marc Louis Emmanuel Solon who had worked for Sèvres as a designer and then for Minton & Co of Stoke-on-Trent in 1871. Léon Solon, born in England, also went to work for Minton & Co. This wonderfully drawn ewer is based on grotesque patterns of the 16th century and has panels of allegorical figures relating to ceramic production. The vessel was conceived as a support for decorative painting of the highest quality, and was probably intended as an exhibition piece to demonstrate the capabilities of Minton & Co and its world-renowned painters. Father and son specialised in grotesque pattern; in 1866 Solon senior had published a set of 50 designs for ceramic and metalwork based on the 16th-century decorations at the French Palace of Fontainebleau.

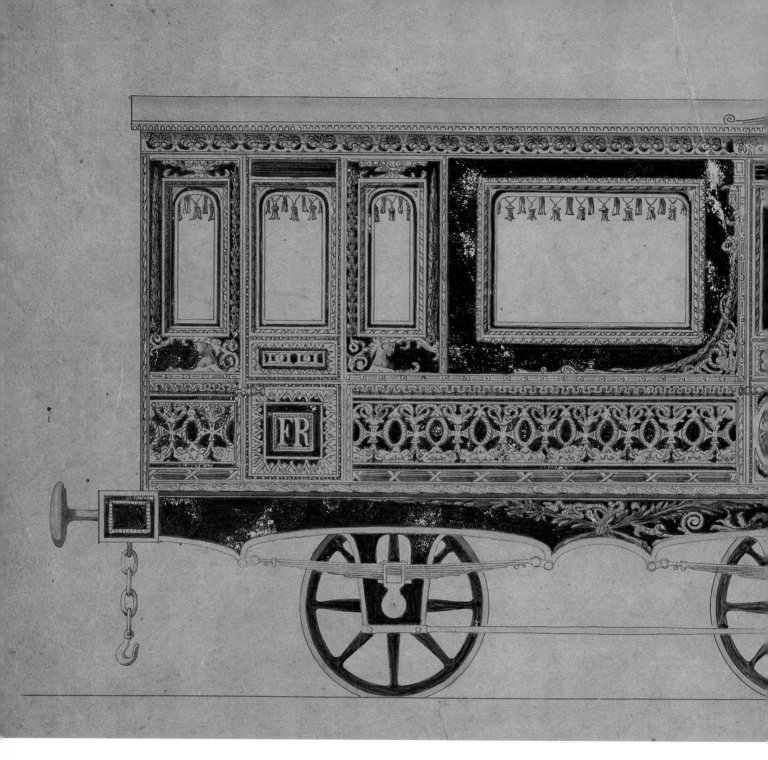

55. Design for the exterior decoration of a railway carriage made for Frederick VII, King of Denmark, by Alfred Stevens (1817–75)

Pen and ink and watercolour 1848. 418-1895

The first railway carriages were just that; a kind of flat car that was loaded with a traditional coach, so that the wealthy could enter and travel in something familiar. The poorer classes had only roofless trucks with benches, although as the railway companies saw the unexpectedly lucrative nature of

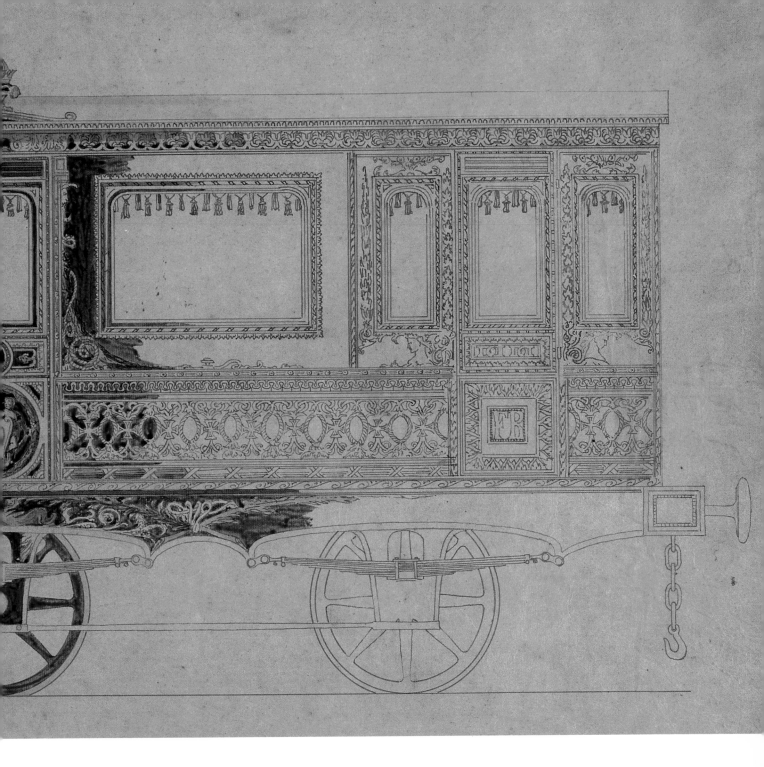

passenger traffic as opposed to goods trains, things soon improved. Queen Victoria was persuaded to travel by train from Slough to Paddington in 1842 and this set the seal on railway travel as a respectable and safe manner of transport. There were no precedents for this kind of vehicle, so designers were set the problem of finding a suitable decorative form that would express the grandeur of royalty within the constraints of an utterly modern technology. Alfred Stevens was commissioned to provide a design suitable for a royal coach and this Italianate carriage is the result.

56. Design for an elaborate brass bed with a draped canopy, by the firm of Robert Lloyd Crosbie and Co (worked last quarter of the 19th century)

Pencil, chalk, water- and body colour c1885. E.2820-1995

The general adoption of metal bedsteads in late Victorian times was heralded by the design reformers and health enthusiasts as a step towards a simpler, lighter and more hygienic interior with much less drapery. Wooden ones were alleged to harbour bugs. However, this and another similar design for an elaborate bedstead show that middle-class interiors, even in bedrooms, were not quite as full of light and air as the enthusiasts might have wished. This design is for the top of the range, the best that the Globe Foundry, Charlotte Street, Birmingham, could do. This particular drawing was one of a pair, framed and hung in the managing director's office, as an example to prospective wholesale customers of the most elaborate lines available. They are not typical of the general run of production – most people had something a good deal simpler.

57. Design for the Doncaster Race Cup, by Henry Hugh Armstead RA (1828–1905)

Ink wash 1854. Given by Montague Pawson. E.2053-1917

Horse-racing and hunting were passionately followed by many Victorian males; there was a kind of hippomania which gripped all classes. The passion for fast cars with all its ramifications would be an approximate modern equivalent. It was considered a necessary accomplishment for a gentleman to ride well, and a patriotic thing too, as skilful horsemanship was still considered necessary in the art of war. Gold or silver racing cups of elaborate form were given as prizes in the biggest competitions and the designs became increasingly sculptural and naturalistic as the century progressed. This drawing by the sculptor Armstead is typical of the designs for silver of the 1850s. Events in British history or historical novels, linked to the locality of the racecourse, were often used. This design illustrates a scene from Sir Walter Scott's novel *Ivanhoe*, which had been published in Edinburgh in 1820. The historical drama was set in the Yorkshire forest of the Prior of Jervaulx Abbey, not very far from Doncaster. The theme of the Prior restraining the Norman knight from striking the impertinent but patriotic Saxons may have had an added resonance in the wake of the social conflicts of the 1840s. It is difficult to know now if this was consciously intended by Armstead, and whether or not it can be read as a text on political oppression.

58. The drawing-room at No 3, Cathedral Close, Winchester, by Barbara O Corfe (exhibited *c*1910–13)

Watercolour c1900. Given by Mrs Henry G Dakyns. E.222-1955

This is one of four drawings recording the interiors of the house of Canon A S Valpy and his wife in a late 17th-century house in the Cathedral Close at Winchester. The drawing-room is an early example of the taste for 'decorating with antiques' which is still current today. Real and reproduction Georgian furniture is mixed with 'Art Furniture' (including a North African table of the type sold by Liberty's) and easy chairs (probably mid-Victorian) disguised under chintz covers, all set on a splendid rug. A further reflection of the same taste for the 18th century is the large collection of ceramics, on open display and in neo-Rococo cabinets. The light colours and airy atmosphere, characteristic of up-to-date Edwardian interiors, are a marked shift from the dark tones of the late 19th century.

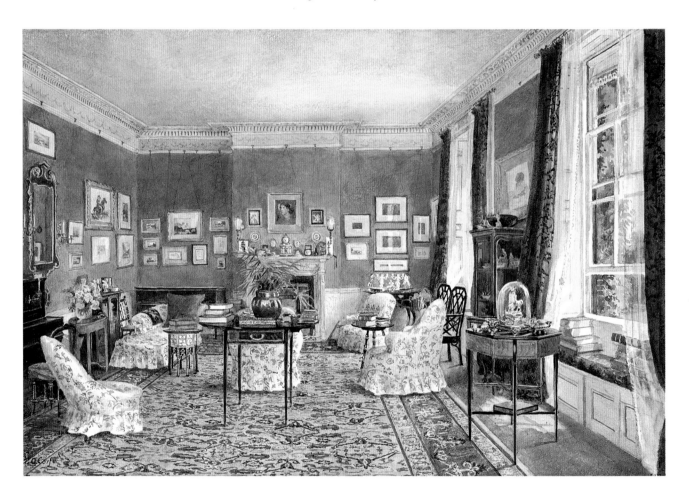

59. View of a living-room, by C W Bodman (worked first quarter of the 20th century)

Watercolour with pen and ink 1909. E.1237-1984

This drawing by an amateur artist is a remarkable record of the appearance of the living-room of a middle-class family which, like most families then and now, could not afford to furnish it completely in line with changing fashion. The large table which, like some of the chairs, dates from the middle of the 19th century has been displaced from the centre of the room by the modern piano. The most up-to-date features are the two built-in 'cosy corner' seats on either side of the fireplace (although their legs seem to have been adapted from earlier seat furniture); and the Art Nouveau grate and tile set in the early 19th-century marble chimney-piece and its mid-19th century curb. Also present are a number of 'Art' pots. The whole effect is unified by the chair- and wall-coverings.

60.

61.

5

Exoticism and Eclecticism

SINCE THE CRUSADES, Britain had been influenced sporadically by a stream of exotic ideas imported as a result of trading with (and sometimes looting from) the East. As more Britons from the mid-18th century onwards went on the Grand Tour beyond Italy to Greece (then in Turkish hands) to Egypt and Turkey, a desire arose to incorporate exotic detail from Islamic and Indian sources into British architecture and design. With some grand exceptions, such as the Islamic interior of Leighton House, London, comprehensive schemes were generally not executed, although exotic elements were introduced as elements of pattern and form in smaller objects such as textiles, wallpapers and ceramics.

60. Diagram showing the anatomical structure of flowers, by Christopher Dresser (1834–1904)

Water- and body colour. 3968

Dresser was appointed as a lecturer in botany at the Government School of Design, London, in 1854. This chart is one of several that survive, showing how he taught botanical drawing. He believed all humans have an underlying appreciation of the geometry of living things (and the patterns that derive from them). He felt that by understanding the basic patterns upon which all things were constructed, you would know how to assimilate apparently widely differing and exotic forms into a logical new style.

61. Vase, designed by Christopher Dresser (1834–1904)

Glazed earthenware 1868. Made by Minton & Co. c.163-1981

62. 'Persian', a page of examples of design for *The Grammar of Ornament*, by Owen Jones (1809–74)

Body colour 1856. 1619

The most important and influential book of designs in Britain in the 19th century must surely have been Owen Jones' *The Grammar of Ornament.* He gathered together examples from civilizations ancient and modern and re-drew them in accordance with his principles of flat pattern. In the printing he used an expensive colour lithographic process which he had helped to improve. Jones included a list of his 'principles of design' (which now totalled 37) in *The Grammar of Ornament,* including the rule that 'all ornament should be based upon a geometrical construction'.

The book was not unprecedented as a compendium of historical and foreign ornament styles. Its radical (and very Victorian) quality was an attempt to systematize all the main branches of ornament, ancient and modern, as if pattern were analogous to language. Thus, the book would be a kind of universal grammar of the process of flat pattern design.

Jones at first did not value Chinese ornament, but later thought better of it and published *Examples of Chinese Ornament* in 1867. The plates in the 'grammar' were of the highest quality, one of his intentions being that his book would be used in schools of design to explain and illustrate the history of ornament and pattern-making and to inspire new designs based on his examples. What he did not want inevitably happened: literal copying of the plates by textile and wallpaper manufacturers. He should perhaps have been more philosophical; better a copy of something acknowledged to be good than an original pattern that did not work.

With the rise of modernism the examples he gave were abandoned in the general reaction against excessive ornament, but now the tide has turned and patterns of all kinds and from everywhere are endlessly plagiarized and recycled, just they were in the 19th century.

63. Design for a Paisley shawl, by George Haité (1825–71)

Water- and body colour c1850. E.4110-1911

Increased mechanization was often blamed for the decline in standards of art and craft. Some design reformers actually believed (and preached) that a machine could never compete with a human being in the manufacture of subtle and delicate things. Yet there are triumphant examples of Victorian

decorative art which no-one could have achieved unless aided by machine technology. Woven shawls made and imported at vast expense from India had become fashionable at the beginning of the 19th century. Made of the finest cashmere wool (collected from the Afghan shawl goat) they were ornamented by small examples of the 'Persian leaf' or '*boteh*', the ancestor of the British 'pine cone' pattern. In 1800 a single shawl of high quality, woven in India, might take two men two years to complete and cost the equivalent of the purchase of a house. The repeats would have to be of necessity small, as the primitive draw-loom system of weaving simply could not cope with the complexities of very large-scale patterns.

Weavers in France and Britain were quick to try to exploit this fashion by producing shawls to imitate the exotic and expensive imports. One major centre of weaving was Paisley in Scotland (hence the name commonly used in Britain) where woven and printed versions were produced. British manufacturers could not hope to compete with the skill of the Indian weavers, so by the 1830s they started to use the punched card system of the semi-automated Jacquard loom. It might take several weeks to translate the pattern drawing into punched

card instructions and lash the cards together in the correct order, but once done it needed only one skilled operator to keep the machine running steadily. The designers were quick to grasp the potential that the machine gave them. Large repeats became feasible, and soon there was furious competition between manufacturers to please the public who wanted bigger and more elaborate patterns in order to make a show. George Haité was a well known and prolific designer of shawl patterns. By 1850 he and his fellow designers were drawing enormous and fantastic all-over pine-cone patterns of brilliant colour, with large repeats, eerily prefiguring the Mandelbrot fractal patterns discovered in the 1970s. The modest '*boteh*' or leaf of 1800 had evolved into something quite new, even more exotic, and economically impossible before early Victorian technology.

64. Design for a frieze in the new style for an upper wall, by Christopher Dresser (1834–1904)

Colour lithograph, a plate from Studies in Design *(1874–6)*. NAL 49 D9 PL.III

Christopher Dresser was perhaps the most inventive of all Victorian designers; unlike William Morris, he worked directly for industrial production. He designed furniture, textiles, wallpapers, linoleum, metal-work, glass and ceramics. It is diffi-cult to sum up his achievements, for he was able to assimilate the most disparate influences and synthesize them in remarkable objects. He was inspired by an extraordinarily wide range of historic and foreign proto-types, including Gothic, Japanese, Chinese, Peruvian and Egyptian. Some design historians claim that he was a pioneer of modern design; this is true only in certain senses. He proved that an eclectic design, that is a pattern built up from widely varying sources, can be reintegrated into a new and modern form. The

strange geometrical shapes of some of his silver- and glassware, however, are not proto-modern in intention, but an expression of his understanding of the underlying geometry of all things, living and inanimate, for example plants and crystals. He made functional studies of vessels, yet this process was different from the 'machine aesthetic' of the 20th century. That his designs sometimes resemble modern 'Art Deco' forms is a coincidence; the thinking behind them was quite different. If there is common ground, it is that both Dresser and his successors were actively seeking a modern style and were trying to avoid limp, literal imitation of past styles.

65. Designs for tiles in Islamic style, by Owen Jones (1809–74)

Pencil and watercolour c1840–50. 8115.5

Owen Jones tried to interest manufacturers in making versions of Islamic tile patterns, and had some success as a tile and mosaic designer in the 1840s. However, although some of the simpler abstract patterns were occasionally used in domestic settings, usually in hallways, they never became very popular with the public. The more austere geometric forms of decoration that Jones had seen and copied in mosques and houses in Cairo never excited much interest in Britain, where a popular taste for naturalism and pictorial decoration in interiors generally prevailed. Cultural differences were too great; a mosque has no canonical need for any imagery at all, and the houses of Cairo traditionally had no pictures of any kind, the only exception being geometrical floral patterns in the panels of stained-glass in the larger buildings, or occasional stylised floral decoration on early tile panels.

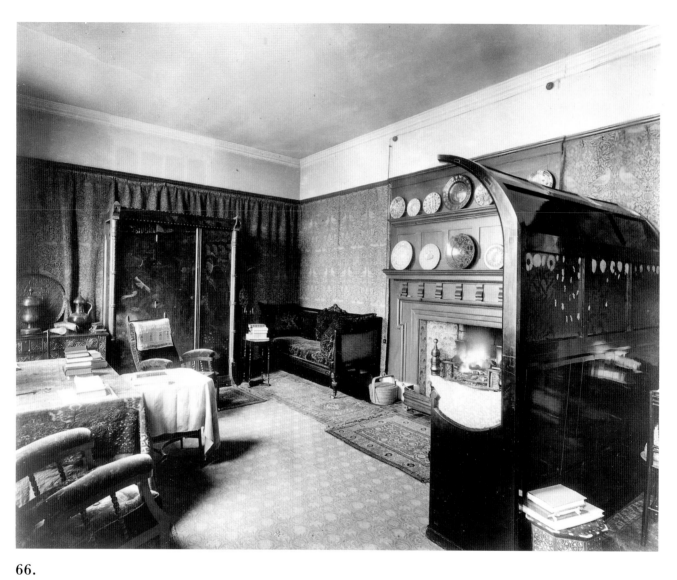

66.

6

William Morris and his Circle

INSPIRED BY Pugin and by John Ruskin, William Morris and Edward Burne-Jones had spent their time at Oxford University together in a kind of medieval dream, trying to recreate the past so eloquently imagined, described and eulogized by novelists as diverse as Sir Walter Scott and Benjamin Disraeli. Morris was a dreamer but a practical one, in the sense that he was not content merely to imagine, but needed to make. A wealthy young man, he spent his money on building a dream home, 'Red House', and furnishing it with objects that he and his friends had designed in the medieval manner. Most wealthy men would have spent their money on employing a fashionable decorator to furnish their homes when they married, but Morris was in many senses exceptional.

It is a great irony, and one of the many paradoxes of the 19th century, that this man did so much to recreate the best bits of the Middle Ages and was influenced by Pugin, the fanatical Christian medievalist, yet he was finally heralded as a pioneer of modernism. The modern movement had theories which rejected nearly all ornament and willingly embraced the machine age, yet somehow had evolved out of a Gothic dreamer's tireless advocacy of beautiful ornament and the craftsman's 'fitness for purpose' while condemning over-reliance on the machine. Morris' stern rejection of the gross commercialism of his own age and his practical attempts to restore some kind of integrity in the arts made him a hero for design reformers in the 20th century.

66. The drawing-room Kelmscott House, Hammersmith, London, by an anonymous photographer

Gelatin-silver print 1896. 2-1973

Kelmscott House was William Morris' London home from 1879 until his death. The photograph shows the main room on the first floor of the 18th-century house overlooking the River Thames. The room is furnished with a mixture of antiques and pieces made by his firm for his previous homes, such as a wardrobe designed by Philip Webb and painted by Edward Burne-Jones with a scene from Chaucer for Red House (1858–9), the settle from Red Lion Square designed by Philip Webb (1856–9), the grate by Philip Webb and lustreware plates by William de Morgan. There are no pictures, the wall being hung with the woven woollen fabric, 'Bird', designed in 1878 by Morris. On the floor is a mix of Persian carpets and Morris' own 'Tulip and Lily', designed about 1875. Kelmscott House was the site of the Kelmscott Press, and the first hand-knotted carpets were woven there before looms were installed at Merton Abbey, Surrey, in 1881.

67. Design for embroidery, by May Morris (1862–1938)

Pencil and watercolour. E.50-1940

May (Mary) Morris had been pressed into service when she was small to embroider after her father's designs, and learnt to design for herself. As a child she had been taught by her mother, Jane Morris, and her aunt Bessie Burden to make large-scale crewel-work (wool) embroideries after Morris' medieval models. In 1885 she took over the embroidery section of the firm and, after Morris' death, she took on Morris & Co and continued to provide for them designs for embroideries large and small, some of which were carried out by women at the Royal School of Needle-work. Her designs are quite distinct from her father's work, although sometimes they have been confused. A number of her designs now exist only as very fragile tracings, although this example has survived better than most.

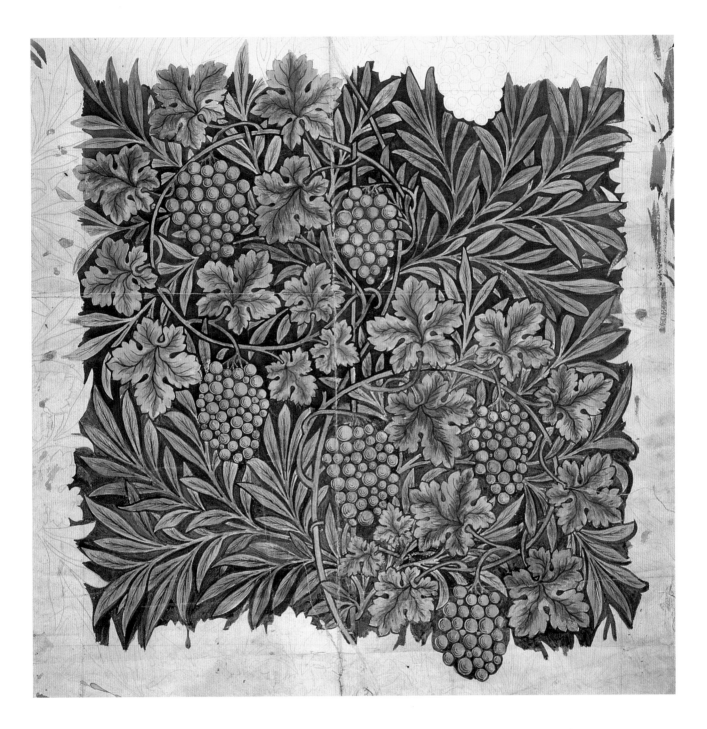

68. Design for 'Vine' wallpaper, by William Morris (1834–96)

*Pencil and watercolour 1873–4. Bought with the aid of a contribution from
the National Art Collections Fund.* E.1074-1988

Between 1872 and 1876 Morris designed 17 wallpapers including 'Vine'. He
combined stylised natural elements with a subtle and complex geometric
structure. Compared to the exquisite drawing skills of his friend Burne-Jones,

Morris' draughtsmanship was not exceptionally good. Yet his understanding and close study of natural forms, allied with his passionate enthusiasm and energy, put him in the first rank of pattern-designers, transcending any defects in his drawing technique.

All Morris' papers were printed by Jeffrey & Co of Islington, London, using wooden blocks, and Morris has annotated the design with detailed notes and instructions to make certain that the workmen printed the paper as close as possible to what he intended. This was never an easy thing to achieve and sometimes, in other branches of his work, had seemed impossible. For example, Morris had been forced to produce printed textiles himself, as he believed no manufacturer of printed cottons could be trusted always to carry out exactly what he wished, using the dyestuffs and the colours he required.

69. Design for a brooch, by Edward Coley Burne-Jones (1833–98)

Pencil c1883. E.8-1895

In the last quarter of the 19th century Burne-Jones was one of the best known painters in the world, wielding a huge influence over painters and designers everywhere. As well as his huge canvasses, he filled a series of

little sketchbooks with designs for paintings and for more intimate things such as jewellery. Jewellery was not for general production by Morris & Co, but made as personal gifts for favoured friends and members of his family. It is neither ostentatious nor directly copied from earlier styles, but delicate and filled with the kind of symbolism much admired by his followers in the Arts and Crafts movement.

70. Sketches for a garden seat and a chair, by Edward Coley Burne-Jones (1833–98)

Pencil on writing paper. E.1000-1976

The smaller sketch for the chair on the right is based on a medieval proto-type, and the artist had actual examples made up so that he could draw them from life. They were used in his tapestry design 'The Departure of the Knights', the first of the San Graal series, as seats for the Knights of the Round Table. Similar chairs were designed subsequently by M H Baillie Scott in 1898 for the Grand Duke of Hesse and C R Mackintosh for the Ingram Street Tea Rooms in Glasgow in 1901. Thus from a rough idea noted down on a piece of his own writing paper, Burne-Jones set in train a design classic.

71. Detail of design for the wall-decoration and cornice in the Green Dining Room, Victoria and Albert Museum, by Philip Webb (1831–1915)

Pencil, water- and body colour and gold 1866. Given by Mr H B Johnson.
E.5096-1960

Morris, Marshall, Faulkner & Co was formed by William Morris and his friends in 1861 as a conscious effort to improve design, particularly in furniture, interior design, stained-glass, textiles and wallpapers. It is recorded that when Morris went to the Great Exhibition of 1851 as an adolescent, he was so overcome with the horror (as he saw it) of the designs put forward as the best that the world could produce, he was violently sick. His response came 11 years later at the 1862 Exhibition in London. His firm exhibited various designs and, although they did not cause any particular stir, they were noticed by Henry Cole. The relatively unknown firm was given the prestigious commission of designing the Green Dining Room in the South Kensington Museum for the Department of Science and Art. This acted as an excellent showcase in the very heart of the government's design establishment. Webb designed the wall decorations and the ceilings, with a splendid moulded frieze of hare and hounds. According to Webb, he was inspired by the same motif carved on the font in Newcastle Cathedral. Webb was justly renowned for his drawings of animals, and the hare reappears in his tapestry designs for Morris.

Burne-Jones designed the stained-glass windows and painted the figure panels. The decorations have survived well, but the room has not been used as a dining room since 1939. The beautifully coloured design by Webb shows the whole treatment of one wall, but does not indicate the delicacy of the moulded work. The deep green used in the colour scheme was much imitated in 'Art' interiors throughout the 1870s.

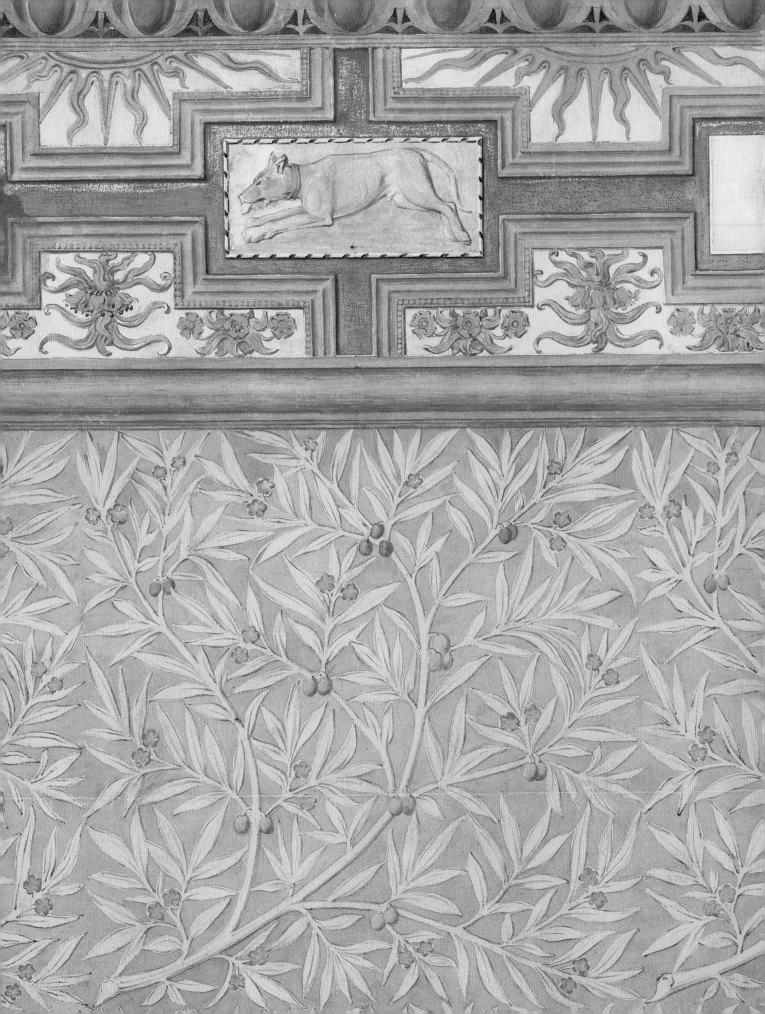

72. Design for a silver teapot, by Philip Webb (1831–1915)

Pen and ink c1897. Given by Miss Joyce M Winmill. E.1-1961

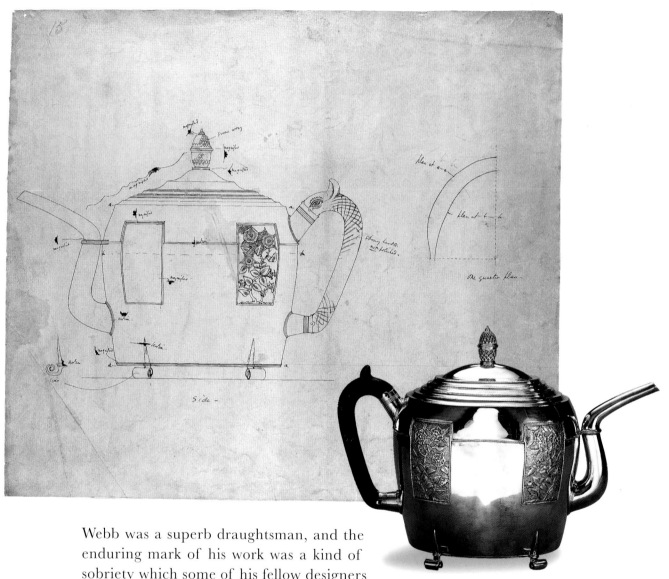

Webb was a superb draughtsman, and the enduring mark of his work was a kind of sobriety which some of his fellow designers saw as severity. This was unjust, as his design for a teapot shows. It has some elements derived from 18th-century examples, but the shapes of the body and spout and the quirkiness of the handle show his originality. Typical of Webb's work are the brief but informative construction notes, accompanied by little sketches showing the profiles and sections of the mouldings and the feet. Webb's architectural drawings left nothing to chance; he always incorporated as much detail as he could, not trusting the craftsmen to improvise anything. Another practical consideration was his belief that more than one drawing of anything only increased the chances of error and dispute, so he incorporated as much information as he could on one sheet.

73. Silver teapot, designed by Philip Webb (1831–1915)

Made by Robert Catterson Smith (worked c1880–1926) 1925. CIRC 499-1956

It is not known whether or not any other teapots made to this design exist. This one, which was completed in 1925, nine years after Webb's death, was commissioned for his own use by Webb's great admirer and disciple the architect Charles Canning Winmill, who carried Arts and Crafts ideas into the public housing and fire stations he designed for the London County Council. He was one of a group of Webb's friends who had saved the architect's drawings, including the teapot design, from destruction at his death. Winmill used Robert Catterson Smith who had made two other recorded designs for silver, and the production of the teapot can probably be regarded as an act of homage to the master.

74. Design for a reading desk, by William Holman Hunt (1827–1910)

Pencil, pen and ink 1868. E.599-1985

Holman Hunt, a founder-member of the Pre-Raphaelite Brotherhood, is best known for his remarkable religious paintings. Yet he made designs for stained-glass as well for Morris & Co. Like his fellow Pre-Raphaelite Rossetti, he designed elaborate frames for his pictures, carved with roundels and loaded with appropriate symbolism. The only design of a similar nature owned by the V&A is this drawing for a reading desk. It is simple and massive, like the Gothic examples Hunt had seen in medieval churches, or in medieval manuscripts or stained-glass. Hunt designed it for his friend William Beaumont, who was curate at St Michael and All Angels Church, Cambridge, but Beaumont died before the commission was completed. The artist eventually kept the reading desk himself.

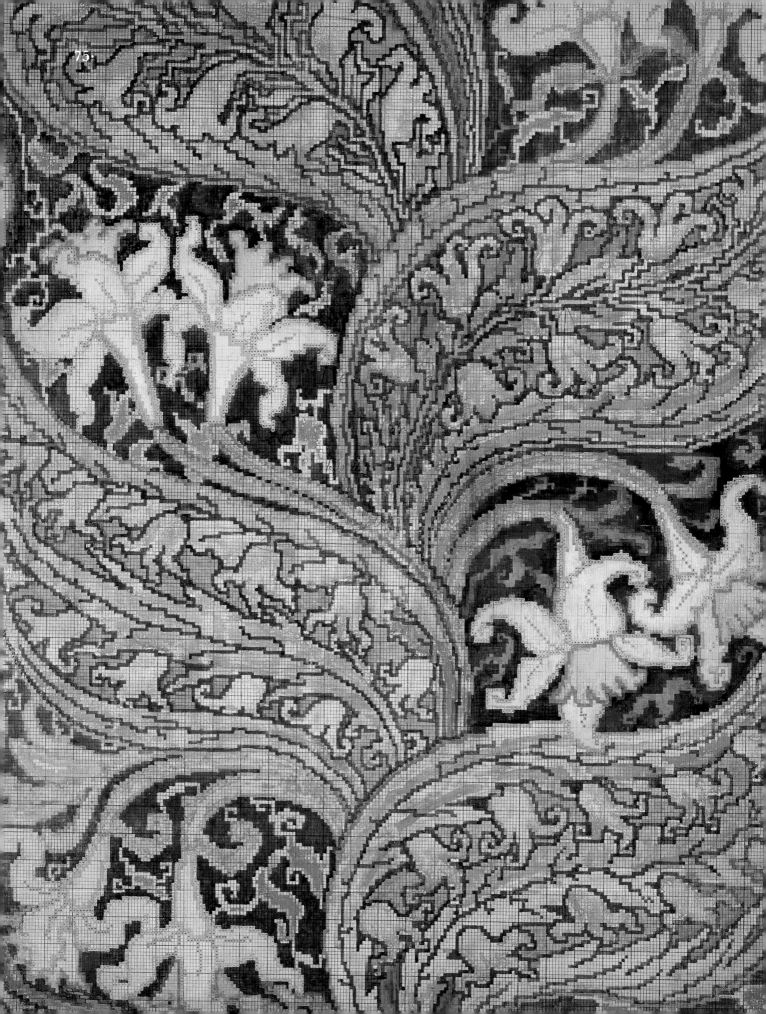

7

Aestheticism and Japonisme

JAPANESE DECORATIVE ART shown in the International Exhibition of 1862 in London had a profound influence, first on artists and designers and subsequently on an aesthetic elite. Most of the architects and designers were practitioners of the reformed Gothic style, but many, in the generation after Pugin, welcomed the idea of combining the Gothic with other styles. Theoretically, it might seem that Gothic and Japanese decorative art could not possibly be put together in an interior in a coherent way, but in practice it was often done. The result in the hands of skilled designers like Godwin and Jeckyll was a kind of high-quality quaintness that was aesthetically appealing but defied rational analysis.

Strange mixtures of styles and cultures were elegantly contrived. For example, the smooth lines of ebonised furniture were inspired by Japan, but some pieces were made in the same media after ancient Egyptian examples. In short, the eclectic habits of a previous generation were continued with a new content. The debate about design and the growth of an educated public who knew about modern painting helped to form a self-proclaimed aesthetic elite. These Aesthetes, as they were called, were passionately interested in art, and separated themselves sharply from the mass by adopting a different kind of dress and life-style from the solid, comfort-loving middle classes who were despised as Philistines. In turn, the Aesthetes were easily identified (and satirized) by their interest in modern art, their devotion to Japanese design and their almost religious intensity in regarding the home as a place of beauty, filled with choice pieces of

textiles and ceramics imported from Japan, India, and China. They believed in the inherent 'virtue' of art objects, an almost mystical quality that things could possess. It replaced the moral qualities that good design was supposed to contain and inspire, as the previous generation of design reformers had preached.

Art, in some circles, replaced conventional middle-class Christianity, and the idea of 'art for art's sake' imported from France became the dogma of the aesthetic elite.

75. Detail of design for a Brussels carpet, by Walter Crane (1845–1915)

Pencil and watercolour c1895. E.2325-1920

Brussels carpets were woven on a semi-mechanised loom, not hand-knotted in the traditional way. This design is technically known as a 'point paper'. Crane's original drawing has been redrawn at a larger scale on special printed squared paper so that the design can be broken down into its smallest and most basic elements for weaving on the loom. Although this sheet is in fact a technical interpretation for a machine and therefore the design is somewhat distorted, the brilliant colour and the designer's skill in pattern-making are still obvious.

76. Design for a dado wallpaper, 'Swan, Rush and Iris', by Walter Crane (1845–1915)

Pencil and body colour 1877. E.17-1945

Walter Crane was most famous in his own day as a book illustrator, but he wanted to be known as a painter. He was much better appreciated as a painter in Europe, where his kind of symbolic subjects were more popular than in Britain. In his illustrated children's books of the 1870s the clever drawings and brilliant colour sense made his work popular with children and adults alike, and they are still in print 130 years later. His most striking innovation was to dress the characters in the most modern style, the clothes of the progressive Aesthetes who were passionately interested in art. The books must have helped reconcile the children of the Aesthetes to wearing what their parents expected them to wear.

Heavily influenced by Burne-Jones, Crane was not able to draw the human figure as well, but excelled in flat pattern design. He began

designing wallpapers in 1874, his name having been suggested to Metford Warner, the director of Jeffrey & Co, by Bruce Talbert. He subsequently became one of Jeffrey & Co's most important designers. This is one of Crane's earliest wallpaper designs. With its black outlines and solid blocks of colour, both of which suggest a study of Greek vase painting, it is typical of his style at this period. Though it has heraldic formality, the motif is naturalistic and pictorial. Typically, Crane's wallpaper designs were figurative, and often narrative, drawing on Greek myth, fairy tales and nursery rhymes. A slightly amended version of this design was produced as a paper two years later by Jeffrey & Co.

77. Perspective design for the billiard room at No 1 Holland Park, London, by Thomas Jeckyll (1827–81)

Pencil and watercolour c1870. E.1797-1979

In 1870 Jeckyll was asked to design a new wing for A C Ionides' house, No 1 Holland Park, London, containing rooms in the Anglo-Japanese manner. This was Jeckyll's first major commission for a decorative scheme. The most consistent example of the style appears to have been the billiard room on the ground floor. A view of the executed room in an album of photographs of the house shows that it differed considerably in detail from the drawing. The house was destroyed in the Second World War.

78. Full-size design for a decorative detail for an ornamental pavilion in cast and wrought iron, designed by Thomas Jeckyll (1827–81)

Pencil and watercolour 1876. Made and exhibited by Barnard, Bishop & Barnard of Norwich. E.5447-1958

A whole generation of designers in Britain was influenced strongly by the Japanese. One of these, Thomas Jeckyll, successfully incorporated favourite Japanese motifs such as the sunflower in his drawings for stoves and ornamental ironwork. This design, 'sunflower panel for lower brackets', was for part of a pavilion in the main building of the International Exhibition, Philadelphia, 1876 and was also shown at the International Exhibition, Paris, in 1878.

This design is part of a set that has survived, though in a fragmentary condition. The cast-iron fire places, mass-produced to his designs by Barnard, Bishop & Barnard of Norwich, were Jeckyll's most durable objects and many must still be in position unrecognised in British homes. A small number of his black lacquer cabinets also still survive.

79. Firedog in the form of a sunflower, designed by Thomas Jeckyll (1827–81)

Made by Barnard, Bishop & Barnard of Norwich 1876. Given by the iron founders Barnard, Bishop & Barnard. CIRC.530-1953

A sunflower motif which formed part of the railings of the pavilion in the main building of the International Exhibition, Philadelphia, 1876 was adapted as a design for a firedog. It was used in the Peacock Room at 49 Princes Gate, London, designed by Thomas Jeckyll and the artist Whistler for the shipbuilder Frederick Leyland in 1877. The walls of the interior, as designed by Jeckyll, were decorated with antique Spanish leather but Whistler over-painted this with a decorative scheme of pea-cocks, to the fury of the owner and the consternation of Jeckyll, who seems never to have recovered from the blow. The interior was eventually removed from the house and is now in the Freer Gallery, Washington, complete with firedogs like this one.

The sunflower motif became a kind of emblem for the Aesthetic movement, and is often seen as a terra cotta decoration on houses built in this period.

80. *(overleaf)* Detail of design for a display of furniture, by Edward William Godwin (1833–86)

Pen and ink and watercolour c1875. E.482-1963

By the 1870s Godwin had begun to produce designs for furniture for the firm of William Watt, inspired by the Japanese use of lacquer. The reliance on smooth, highly polished surfaces and elegance of form, in-stead of applied decoration on traditional shapes for his tables and chairs, is prophetic of the modern movement of the next century. This drawing could be for a shop display of William Watt's but is more likely to be for a stand in a major international exhibi-tion, of which there were several in the 1870s and 1880s.

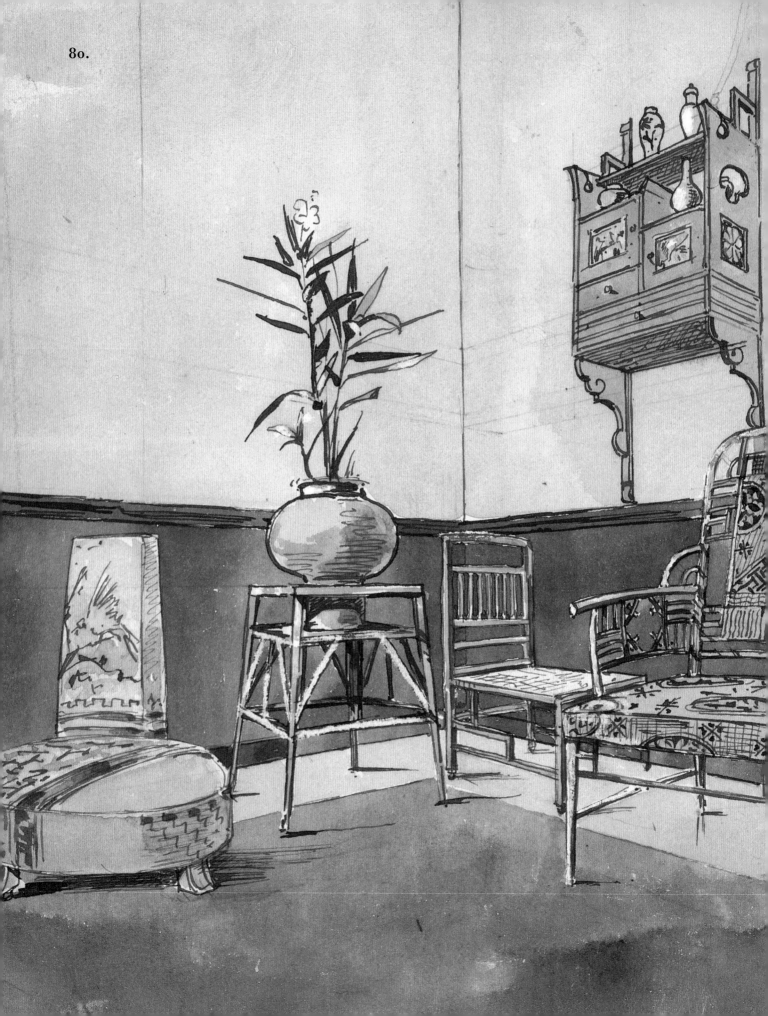

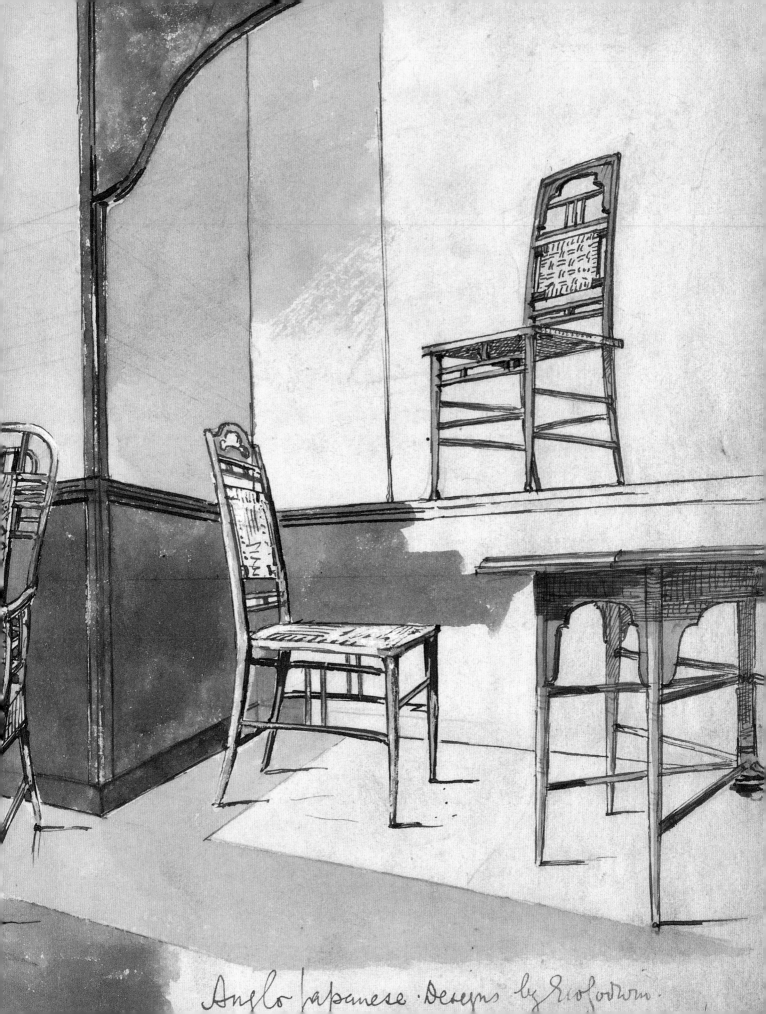

Anglo Japanese Designs by E.W.Godwin.

81. Design for a wall decoration at Dromore Castle, Ireland, by Edward William Godwin (1833–86)

Pencil and watercolour c1868. E.491-1963

This design seems to be the earliest example of Japanese influence on Godwin's work. The imagery owes an obvious debt to Japanese prints, and includes panels of William Morris' 'Trellis' wallpaper of 1862 – originally inspired by rose trellises in the garden at his home, Red House. The notion of combining an English country garden motif with Japanese images to form a harmonious decorative scheme for the interior of an Irish castle is typical of Godwin's eclectic approach. Perhaps the framework of the trellis pattern suggested to Godwin a similarity to the square panelled paper screens shown in prints of Japanese interiors.

Gothic art was a product of a medieval society which had been superseded. Japan, in complete contrast, had retained a living medieval – and feudal – tradition until the middle of the 19th century. Some of its pre-Renaissance attitudes to craftsmanship, art and design were similar to the Gothic that Godwin and others were trying to revive.

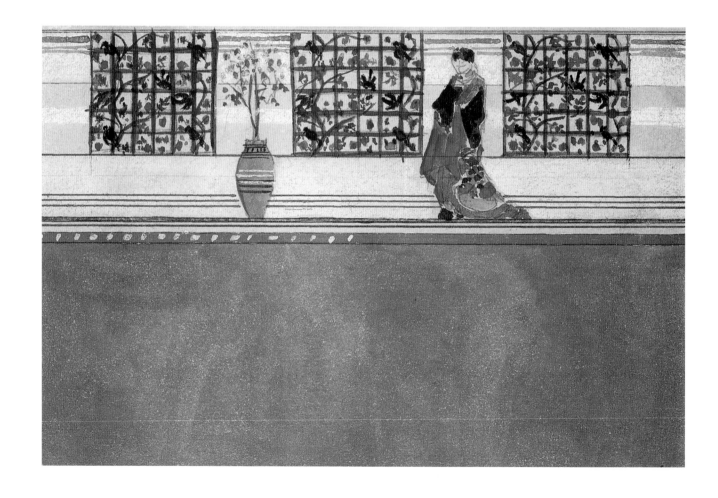

82. Design for a woven textile, by Bruce J Talbert (1831–81)

Pencil, water- and body colour c1875. E.91-1974

Bruce Talbert had begun as a designer in the reformed Gothic style. Like many others of his generation he was heavily influenced by Japanese design which he had first seen in any quantity at the International Exhibition of 1862. The Japanese were expert at the production of infinitely varied geometric patterns, carried out in many media, the most accessible to the West being silk textiles and metalwork. Talbert designed textiles which were freely ornamented with Japanese stylised and abstract motifs. This design for a woven silk was woven by Messrs Warner & Son of Braintree, Essex, who commissioned many designs from prominent designers in the late 19th and the 20th centuries. Japanese lacquer-work excited admiration and then imitation and Talbert, like Godwin, produced rather severe black lacquer cabinets and other furniture in the Japanese style.

83. Original cartoon for tile panels in the Grill Room of the Victoria and Albert Museum, designed by Edward John Poynter (1836–1919)

Pencil and watercolour 1870. 7916.10 OCTOBER

84. Tile panel in the Grill Room (formerly known as the Dutch Kitchen) of the Victoria and Albert Museum, after the designs by Edward John Poynter (1836–1919)

Poynter was a painter who specialised in pictures set in the ancient world of Greece, Rome or Egypt, often on a large scale. His work, like that of his contemporary, Alma-Tadema, was based on careful reading of archaeological research. He also provided designs for stained-glass, furniture and tiles. He taught at the South Kensington Schools and was commissioned by the South Kensington Museum to provide large figure panels and other decorations for the Dutch Kitchen (later known as the Refreshment Room and now the Grill Room) which acted as a showcase for the latest design thinking. Poynter was a good draughtsman and his lively treatment of the human figure enabled him to give a sense of life and movement to the conventional series of the 12 months. 'October' is particularly dramatic as her drapery is swirled by the raw winds of that month. The tiles are partly based on techniques perfected by the Dutch, yet these large figure panels are a kind of advertisement for the Aesthetic movement and therefore at the time were at the height of fashion.

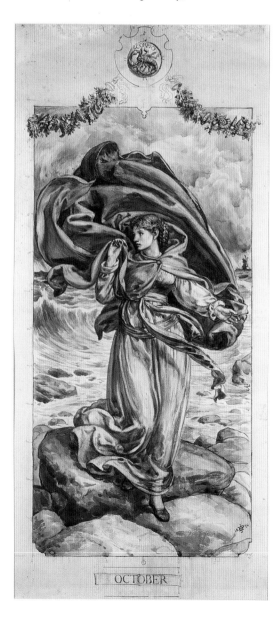

The tile panels were painted by the members of the female school at the School of Design at South Kensington, and the iron stove and grill in the room was also designed by Poynter in a Japanese style. It remained in daily use from 1868 until 1939.

OCTOBER

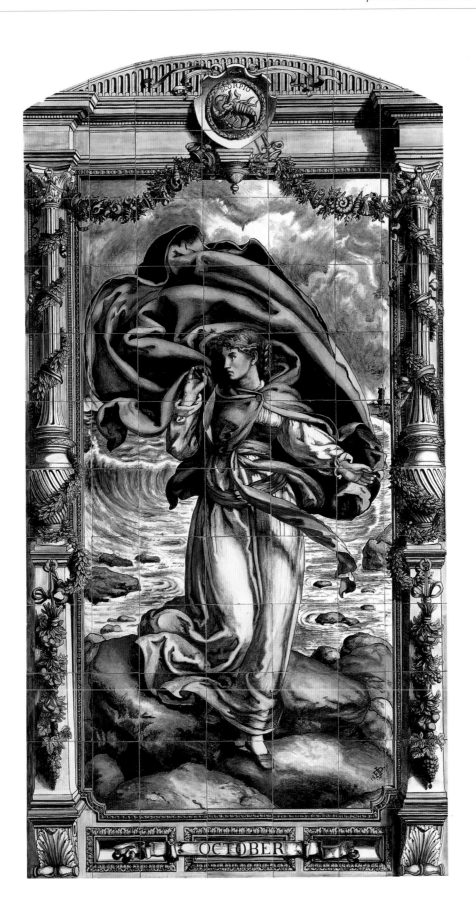

85. 'The Grotesque', design for a printed textile, by Lewis Foreman Day (1845–1910)

Pencil and watercolour 1886. E.245-1954

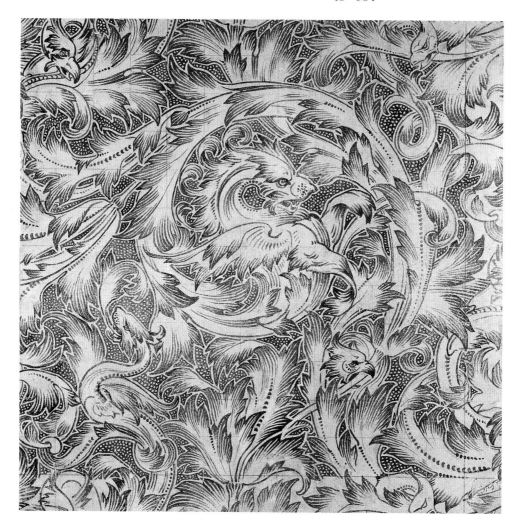

Lewis F Day's fame has been eclipsed by his contemporary William Morris, although he was as well known a designer in his time. Day was an advocate of 'conventional' treatment of floral forms; that is the drawing of a plant form would be treated according to certain conventions of representation and not be a picture of any individual specimen. So although the varieties of the flowers would be recognisable, their rendering would be to some extent simplified and stylised, rather like the Japanese drawing of plants. He was the author of many books and articles on aspects of ornament and design, and was an examiner at the South Kensington School of Design, the ancestor of the Royal College of Art. This crisply drawn design is a stylised modern version of traditional acanthus scrolls, populated by strange beasts, in the manner of 14th-century manuscript decoration.

86. Design for a key plate, by Lewis Foreman Day (1845–1910)

Pencil and watercolour 1895. E.1037-1911

Day was an advocate of close attention to detail in pattern-making and design, and wished to apply decoration to relatively humble objects, particularly where they were noticeable. It was possible to buy utilitarian key or door plates cheaply, but if these were unthinkingly used in an interior which had been designed and composed on aesthetic principles, they would have ruined the effect at once. Day's solution was to design as much as possible in a room, even the most ordinary fittings, as architects following the example of Robert Adam had done.

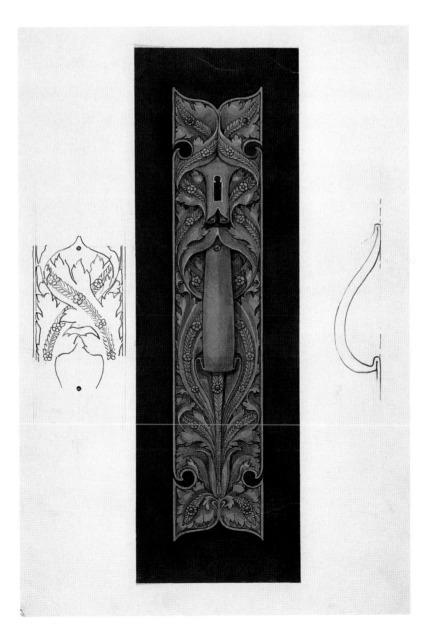

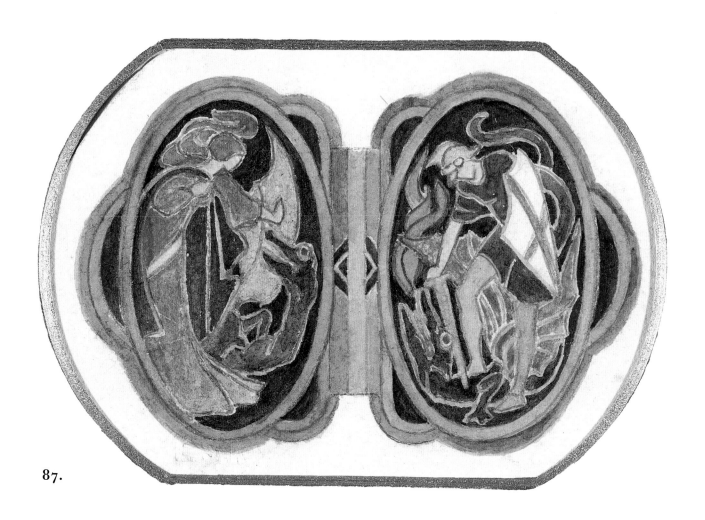

87.

8

Arts and Crafts

THE ARTS AND CRAFTS MOVEMENT was a loose assemblage of architects, designers and craftsmen who shared the ideals of Pugin, John Ruskin and William Morris. They sought 'truth to materials', honesty of construction, traditional forms and appropriate and restrained ornament. They distrusted the machine, and especially the mainstream commercial manufacturers. They hoped that the public would adopt their utopian vision of a society where only necessary and useful things would be made by skilled designer/craftsmen and -women. They formed various guilds and societies, but the Arts and Crafts Exhibition Society was probably the most influential. Its first show was in 1888 in London and the Society continued to hold exhibitions into the 1920s.

87. Detail of design for a belt-buckle in enamel, by Norman Ault (1880–1950)

Pencil and watercolour c1898. E.3262-1991

Norman Ault made this design when he was a student at the South Kensington schools. It clearly shows the influence of William Morris in the choice of subject, the story of St George and the Dragon and Princess Sabra, which Morris had used in the 1850s to decorate painted furniture. The buckle would have been intended for use with an Arts and Crafts dress, a romantic and loose flowing gown which contrasted sharply to the stylish corseted hourglass figures of late Victorian and Edwardian women's dress. The gulf between fashionable dress and what the supporters of the Arts and Crafts movement were wearing grew ever wider at this period.

88. View of the dining room at The Ancient Magpie and Stump, 37 Cheyne Walk, London, attributed to Fleetwood C Varley (1863–1942)

Pencil and watercolour c1901. Reproduced in Kunst und Kunsthandverk *(Vienna, 1901) vol 4, p 464.* E.1903-1990

The Ancient Magpie and Stump, which was demolished in 1968, was built by the architect and designer Charles Robert Ashbee (1863–1942) in 1893–4 on the site of an old public house of the same name. Chiefly intended as a home for his mother and sisters, but also containing his architectural office, the rooms in the house were the first evidence of Ashbee's talents as an interior designer as well as a much-publicized demonstration of the work of his Guild of Handicraft. The remarkably austere dining room, with its narrow guild trestle table and ladder-back chairs, was decorated only with a modelled plaster frieze, partly painted by his daughter Agnes, and a sideboard displaying blue and white porcelain. The lighting, by contrast, was ultra-modern electric, in guild fittings.

Ashbee had founded the Guild of Handicraft, a school and subsequently a business squarely based on Arts and Crafts principles, in 1888 and it practised woodwork, leatherwork, metalwork and jewellery-making. At first it

was established in London's East End, but it moved out to Chipping Camden in Gloucestershire in 1901, partly to embrace the rural ideal. The guild was much admired by intellectuals, particularly from outside Britain. Its elegant jewellery and silver designs were successful at first; so much so that they received the royal warrant as jewellers and silversmiths to Queen Alexandra in 1901. In 1907 the business failed, mainly because it could not compete with ordinary commercial firms, especially with Liberty's range of 'Cymric' silver and jewellery. In addition the subdued British Art Nouveau style of its products became less fashionable after 1905.

89. Peacock pendant with chain, designed by Charles Robert Ashbee (1863–1942)

Enamelled silver, set with semi-precious stones 1901. Made by the Guild of Handicraft. M.23-1965 (21 F 3)

90. *(overleaf)* Design for a room, signed with monogram and dated, by William Richard Lethaby (1857–1931)

Pen and brown ink, ink watercolour and coloured chalks, heightened with white 1885.
E.199-1990

This striking design, which was made when Lethaby was chief assistant to the architect Richard Norman Shaw, is an example of his attempts to create a modern style for the late 19th century. The vaulted ceiling and tall panelling are directly inspired by the neo-Jacobean country-house style of Shaw or Sir Earnest George, although they are painted Morris green (as in the Green Dining Room at the V&A). The decorative motifs, furniture and other ornaments, however, are chiefly ancient Greek, culminating in a starkly flat marble fireplace decorated with the symbols of the four elements. The Greek treatment was probably inspired by a visit to the studio of Sir Lawrence Alma-Tadema which had been decorated in the Greek style in 1884 and contained a chair exactly like the one shown here. This drawing was probably exhibited at the first exhibition of the Arts and Crafts Exhibition Society in 1888 under the title 'Design for the decoration of a room in panelling and paint'.

90.

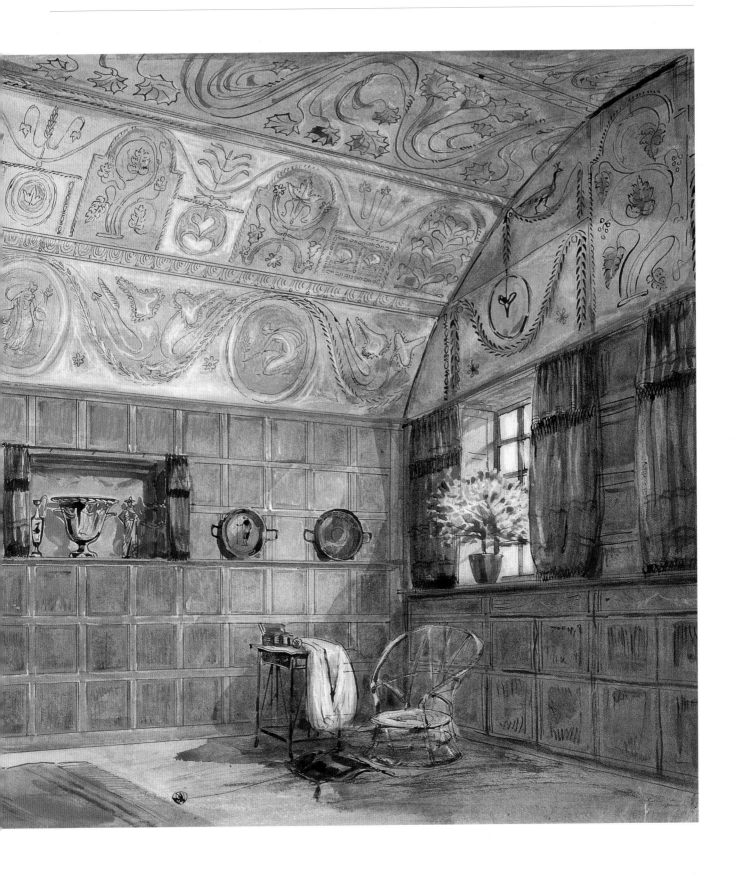

91. Design for a set of bath taps and pipes, by Nelson Ethelred Dawson (1859–1942)

Pencil and watercolour 1900. E.717-1976

Nelson Dawson was a frequent exhibitor at the Arts and Crafts Exhibition Society; he and his wife Edith Dawson specialised in enamel work. They believed as Morris had before them that harmonious principles of design should be applied to decorate any kind of object no matter how humble or utilitarian, as ugliness was to be banished entirely from the home. Taps were an ancient technology, but the advent of modern plumbing in the latter half of the 19th century meant that the bath tub could now be fitted with a pair of large and obvious pieces of mechanism which cried out for ornamentation, but not necessarily in the style of the normal Birmingham manufacturer. Dawson had them made in his own workshops.

Here Dawson has applied his imagination and provided a sculptural design for taps which even now look more refined than the gold-plated excesses of some modern plumbing.

92. Bath taps, made in the workshops of Nelson Ethelred Dawson (1859–1942)

Coppered and silvered Britannia metal bath taps 1900. CIRC. 191-D-1963

The problem was, as always, that only a wealthy client could afford to have such magnificent taps specially made. These taps and other Dawson fittings were made for Greenlands (near Henley-on-Thames, Oxfordshire), the house of William Frederick Danvers Smith, 1st Viscount Hambleden, who was a senior partner in the firm of W H Smith.

93. Design for the interior of Munstead Corner, Surrey, by Edwin Landseer Lutyens (1869–1944)

Pencil, pen and ink and watercolour 1891. E.1-1991 P.36

Lutyens possessed a very useful skill which enabled him to attract clients for his magnificent and expensive buildings. He would produce little sketches which looked as if they had been drawn from actual examples of the English vernacular style that he might have come across on a tour of the countryside. Sketching tours to picturesque parts of Britain, and indeed to France and the rest of Europe, were part of a greater nostalgia for the pre-industrial quaintness of the past.

The lineaments of his new buildings were complex and beautiful, yet so familiar and re-assuring that – if the client was willing to pay – a house with an instant 'place' in the landscape would soon appear. With skilled planting of the garden, often

with the aid of his colleague Gertrude Jeckyll, the house would soon look as if it had been nestling in the wold since medieval times. Lutyens' buildings exerted great influence on succeeding generations of architects and persists to this day.

94. 'Tiger lily', design for a printed textile, by Lindsey P Butterfield (1869–1948)

Pencil and watercolour 1896. E.68-1961

Lindsey Butterfield studied at the National Art Training School at South Kensington from 1889 to 1891 and his designs, like those of many of his contemporaries, are superb examples of draughtsmanship. He went to work for the Silver Studio, an influential design firm which produced many patterns for wallpapers and textiles up to the 1950s. Butterfield's early designs were based on plant forms that were recognisable but subtly stylised, deriving their inspiration ultimately from William Morris and then Voysey. The close study of the underlying geometry of plants, which had been advocated in the design schools, particularly at South Kensington, was at last bearing fruit.

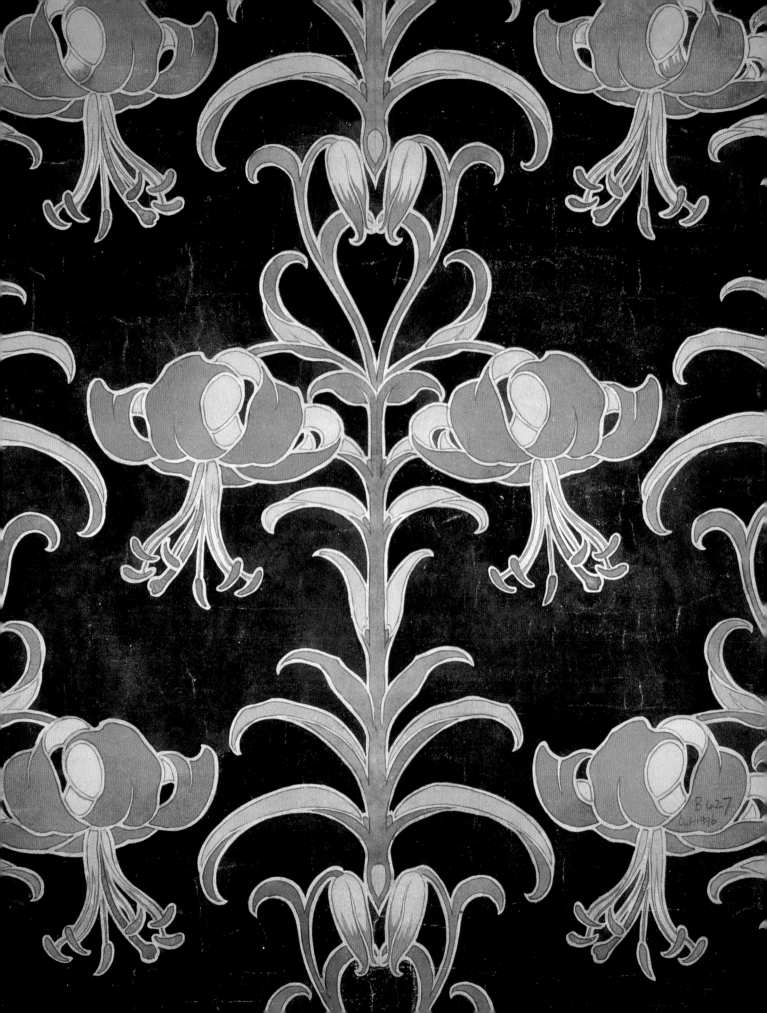

95. Vase and cover, by William de Morgan (1839–1917)

Earthenware with painted decoration and lustre. C.413 & A-1919

William de Morgan had studied at the Royal Academy schools and had been a close friend of Morris, Burne-Jones and Rossetti since the early 1860s. In 1882 he moved his workshop to Morris' Merton Abbey works in Surrey. He was primarily a decorator of ceramics which were intended for display, not hard practical use. He regarded the vessels, usually made by others, as a surface for his elaborate painted designs. His decoration was inspired by a mixture of sources, especially Turkish 16th-century wares from Iznik, and 13th-century Persian lustreware. His work was like these historic examples in that it was magnificent in design but painted onto soft slip-covered earthenware made in imitation of Chinese porcelain.

He assimilated these influences into his own distinctive style of flat abstracted design. His output appealed to the wealthy, sophisticated tastes of people like Morris and the painter Lord Leighton, both famous collectors of de Morgan's work who also collected original Persian ceramics. When Lord Leighton needed more tiles to complete his famous Islamic fountain room at Leighton House, London, de Morgan made close imitations.

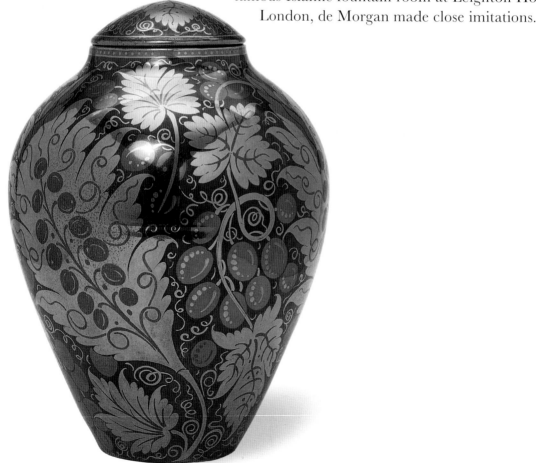

96. Design for the decoration of a vase, by William de Morgan (1839–1917)

Pencil and watercolour. E.1384-1917

Most of de Morgan's designs on paper were bequeathed to the V&A, and they are an invaluable resource for the identification of unmarked pieces. Many of the surviving patterns are pricked through, in the traditional way, so that pigments can be dusted through onto the ceramic in a kind of stencil process, giving faint outlines for the painters to follow. De Morgan arranged for tiles and some of the vessels to be produced in Italy using this method, as it was the only way that he knew of preserving the integrity of the designs without descending to exact mechanistic copying.

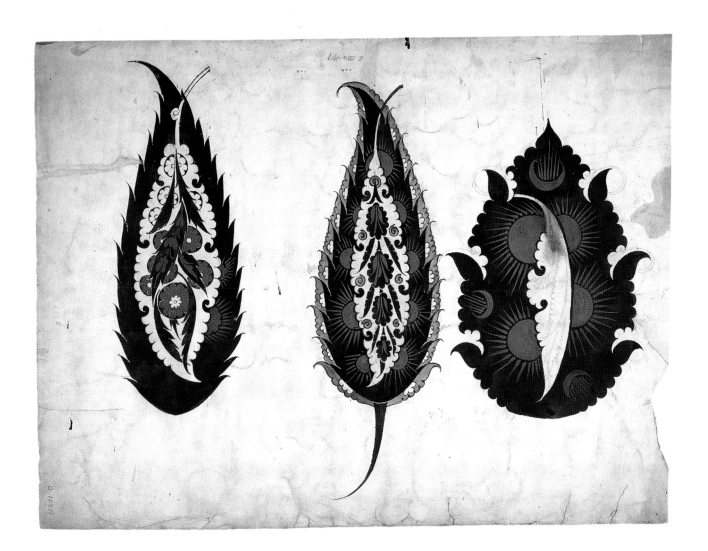

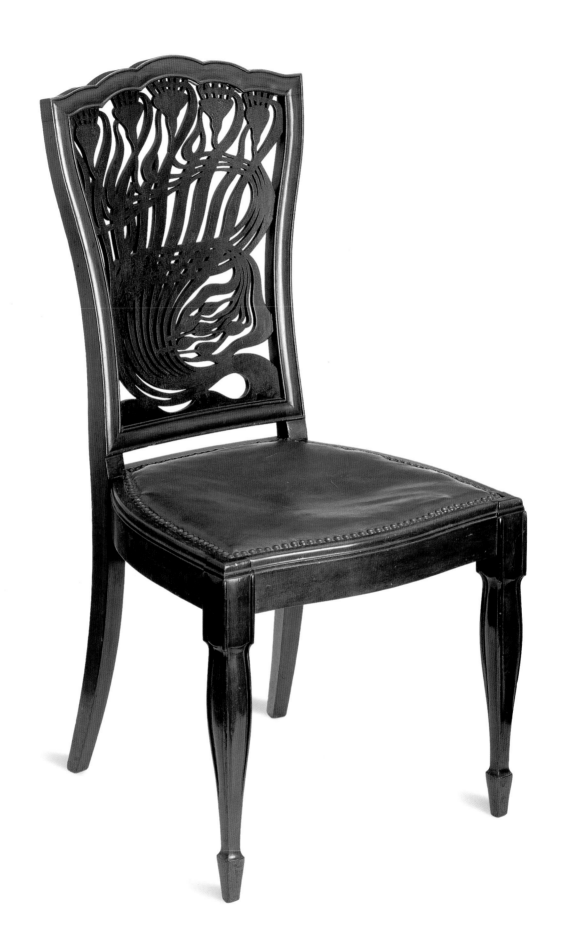

9

The Origins of Art Nouveau

ART NOUVEAU and its origins are still controversial subjects. This is not surprising, as the style aroused fierce passions in Britain at the height of its popularity between about 1895 and 1905. The full-blown swirling forms of French and Belgian Art Nouveau were increasingly distrusted by designers in England, paradoxically often by those who had contributed unwittingly to its development. Somehow, foreign Art Nouveau forms were perceived as decadent and immoral – though they seem harmless enough now.

New ways of painting had developed in Europe and America since the 1870s. Although the movement was international in spirit, its subsequent expression in the decorative arts of the 1890s reflected and sometimes exaggerated the national traditions of the individual countries. The underlying force was the same, but each nation used the new energy to evolve different forms. Sensuous, luxuriant French Art Nouveau designs proved too much for some of the more austere British designers.

In Britain, in the period 1890–1905, there was a respectable number of extremely skilled draughtsmen and women providing magnificent floral patterns which are the British equivalent of Art Nouveau. The schools of design, although they had been suggested before Victoria came to the throne, are essentially a Victorian achievement. The presence of so many art schools throughout Britain meant that there was, at the very least, a substantial pool of rigorously trained and sophisticated artists and craftsmen who could draw. This is perhaps the biggest and most noticeable difference between the beginning and the end of the

Victorian period in design terms. The average pattern-designer in the 1840s was markedly inferior in skill to his or her French equivalent, but by 1890 this difference in accomplishment had all but disappeared. The patterns produced in Britain were second to none and briefly exerted great influence on the rest of the world.

97. Chair, designed by Arthur Heygate Mackmurdo (1851–1942)

Made by Collinson and Lock c1882. w.29-1982

This chair is often cited as one of the first three-dimensional objects that foreshadowed Art Nouveau. The asymmetric fretwork pattern set in the back contrasts in its modernity with the traditional style of the rest of the chair. The restless sculptural form of the sea lily pattern may have been inspired by a group of spectacular fossils, minutely preserved in fine-grained limestone, rather than by living examples.

98. Design for a wallpaper or a textile, by Arthur Heygate Mackmurdo (1851–1942)

Charcoal, water- and body colour c1882. E.1165-1920

As a young student of architecture, Mackmurdo was profoundly influenced by the drawings of the painter Burne-Jones, whose swirling patterns for stained-glass in the 1870s prefigure Art Nouveau. With the aid of his friend and fellow-designer Selwyn Image, Mackmurdo developed an eccentric style that took natural forms into a new kind of abstraction. A favourite quirk, much imitated by practitioners of Art Nouveau later on, was to base patterns on real but unfamiliar and strange-looking natural forms. In the design illustrated here he has used the crinoid, or sea lily (in fact a kind of primitive animal related to corals). Mackmurdo is known to have attended illustrated lectures on exotic seaweeds, and it is possible that he was also inspired by 'bizarre' English and French silk designs of the late 17th century. This drawing is signed with the monogram of the Century Guild (CG), founded by Mackmurdo in 1882.

99. Details from a sketchbook of designs, by Herbert Day (worked late 19th century)

Pencil, pen and ink and watercolour c1900. E.216-1991 P 51 & 52

British Art Nouveau furniture of a modest and non-flamboyant kind became relatively popular by the late 1890s, and perhaps was the only 19th-century style that did not refer mainly to the past or to other cultures. The Aesthetic movement, the Arts and Crafts movement and continental Art Nouveau were not taken up on a large scale by manufacturers, but many pieces of bedroom furniture in a relatively subdued British Art Nouveau style were sold to a wide public. This style of furniture persisted into the 1920s as its simplicity and cheapness recommended it, whereas other kinds of Art Nouveau, especially textile and wallpaper patterns, were displaced by a revival of naturalistic patterns, typically English roses, after about 1905.

100. *(page 135)* **Detail of design for a wallpaper, by Herbert Percy Horne (1864–1916)**

Pencil, water- and body colour c1886. E.1166-1920

Herbert P Horne was a pupil of Mackmurdo and went on to design houses, interior schemes and a chapel. He joined Mackmurdo's Century Guild in 1883 and was in partnership with him from 1885 to 1890. His watercolour drawing was particularly attractive and he was a less eccentric pattern-designer than his master. This deceptively simple pattern has not been illustrated as often as his more famous 'Angel with Trumpet' design for printed cotton, but shows his skill in making a subtle new kind of pattern out of traditional floral forms. The wallpaper was printed by Jeffrey & Co of Islington, who also produced William Morris' wallpapers. Like many Victorian designers, pattern-making was only one of his interests, and eventually he went to Florence, lived in the Palazzo Horne, gave up designing and became the first modern scholar to study and publish the work of the painter Botticelli.

101. Design for a writing desk, by Charles Frances Annesley Voysey (1857–1945)

Pencil and watercolour 1895. E.274-1913

Elegant simplicity was the quality that Voysey admired most in traditional furniture, but his own designs have an additional subtlety and stylisation which is immediately recognisable as modern. In this design for a writing desk, Voysey refers to the past by using the natural patterns of oak graining emphasised by the rich monotone of the burnished copper. He produces a new kind of decorative motif, however, by extending the copper mounts way beyond their immediate function, using his superb drawing skills in producing pictures in silhouette. Furniture of this kind was designed specifically for his houses, which combined the best features of traditional vernacular architecture with modern practice. As his houses reflected the past, but improved on it without radical or eccentric departure from tradition, so did his furniture.

102. Writing desk, designed by Charles Frances Annesley Voysey (1857–1945)

Oak with copper fittings 1895. W.6-1953

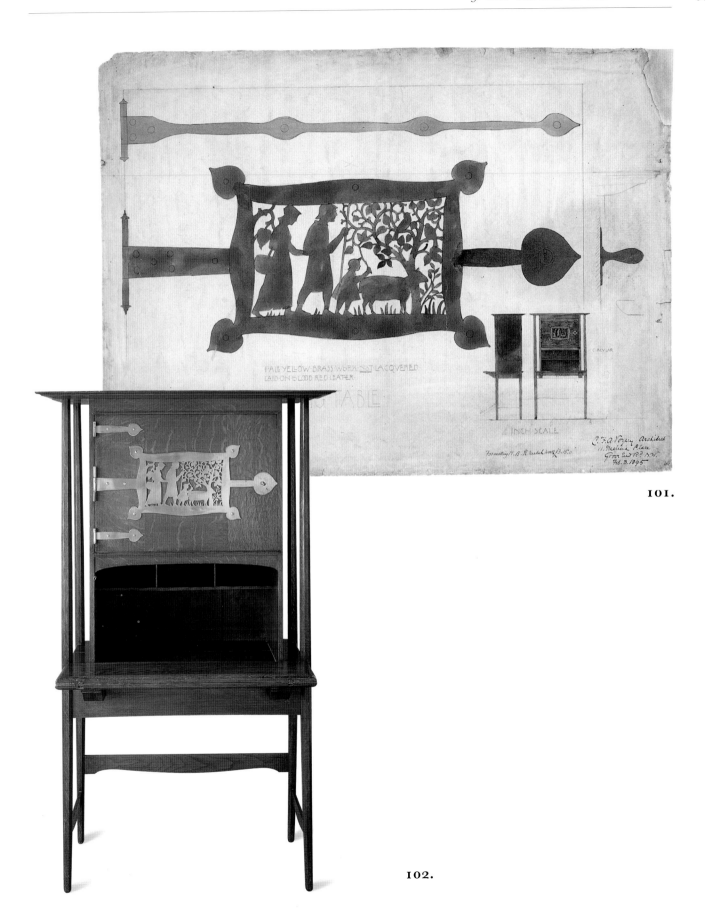

101.

102.

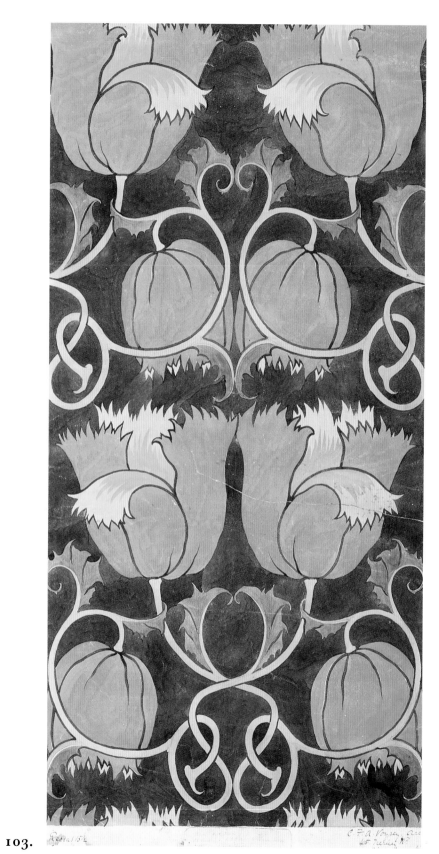

103.

103. Design for a printed textile, by Charles Frances Annesley Voysey (1857–1945)

Watercolour c1888. E.61-1961

The architect Charles Voysey is now recognised as one of the greatest pattern-designers of the late 19th and early 20th centuries. His textile and wallpaper designs are in direct line of descent from those of William Morris. He was influenced also by his friend A H Mackmurdo. In 1888, about the date of this design, Voysey exhibited at the Arts and Crafts Exhibition Society in London, showing textiles and wallpapers. The show that year was a great success and received wide publicity, even on the continent. It is still a matter of dispute how much influence designers like Voysey and his contemporaries had on the development of Art Nouveau; he and his British colleagues certainly tried to distance themselves from the later continental manifestations of the movement. Although his dramatic stylisation of the large-scale floral forms looks forward to Alphonse Mucha's graphic designs, Voysey, an austere man, could not accept that he played any part in the development of that exuberant style.

104. Designs for furniture, by Messrs Waller & Sons (worked last quarter of the 19th century)

Pencil, pen and ink and watercolour c1895. E.552-1975

Waller & Sons of Lyall Street, Belgrave Square, London, were decorators who worked mainly for wealthy clients in Belgravia. The firm had provided a large number of designs in the Anglo-Japanese manner in the 1870s. They kept up with the changes in fashion when the brief period of British Art Nouveau started in the 1890s.

105. 'Omar', design for a silk and wool double cloth, by Charles Harrison Townsend (1852–1928)

Pencil, water- and body colour. E.593-1974

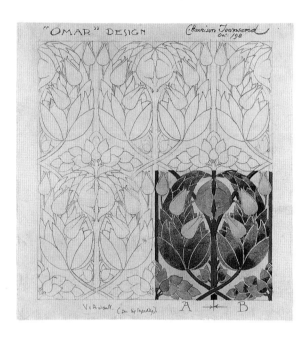

Townsend is best known as an architect who designed some spectacular churches as well as secular buildings such as London's Horniman Museum and Whitechapel Art Gallery. This design for a woven double cloth is partly based on a Persian motif, hence the name 'Omar', but it also has some of the characteristics of British Art Nouveau. Yet Townsend, as a member of the Arts and Crafts movement, would have rejected any connection with his work and continental Art Nouveau.

106.

106. Design for the north wall of the main bedroom, Hill House, Helensburgh, Scotland, by Charles Rennie Mackintosh (1868–1928)

Pencil and watercolour 1903. E.841-1968

Hill House was designed for the Glasgow publisher Walter W Blackie in a fashionable commuter town and is set on a hill-top with superb views. Blackie wanted a 'practical house' and Mackintosh designed every detail. The exterior is derived from the Scottish vernacular but the interior is startlingly innovative. The design shows a wall of fitted wardrobes for the L-shaped bedroom which is located at the end of a corridor, for privacy. The use of white lacquer contrasts with the black finish of some of the furniture. The wardrobes are decorated with squares of leaded glass and show Mackintosh moving away from the stylised naturalistic decoration of his earlier work to more rigidly geometric patterns.

107. Casket, by Charles Rennie Mackintosh (1868–1928)

Beaten brass 1896. CIRC 111B-1962

Mackintosh designed and made this jewel casket for his first fiancée Jessie Keppie. There is a rather poignant contrast between the subtlety of the design and the rather amateur finish of the object. The union of craftsman and designer in one person was an ideal of the Arts and Crafts movement, and still is amongst some of those who practise the crafts. Yet very few individuals were able to design and then make high-quality work themselves with equal levels of ability. Mackintosh's superb design skills were not matched by his practical craftsmanship. Most of the leading figures in the movement, especially the architects, had to rely on others to execute their work, apart from special cases like enamels and jewellery. Wallpapers and textiles, with the notable and partial exception of those of William Morris, were nearly always produced in quantity by specialised firms. The best pieces of Mackintosh's furniture and metalwork were made by commercial firms in the traditional relationship of designer and craftsman.

Index

Acknowledgements

This book is part of a series on the designs collection of the Department of Prints, Drawings and Paintings, which is intended also to include volumes on Georgian and 20th-century designs. All I know about Victorian design has been learnt from my colleagues over many years, and from studying and making the design drawing collections accessible to the public via the Print Room. I must, however, acknowledge the help with this book given to me by the members of the Research Department. Paul Greenhalgh and Malcolm Baker, who run the Department, were very encouraging, and the book would not have been possible without their support and the time I spent there. Clive Wainwright was particularly generous with detailed information not only about Victorian design, but its social context as well. I must also thank Clare Phillips for information on metalwork and jewellery design and Karen Livingstone from the British Galleries team who gave me useful advice.

As for my own Department, I must thank Susan Lambert, the Keeper of Prints, Drawings and Paintings, and especially my colleague, Michael Snodin, Head of the Designs Collection. I am indebted to my colleagues Fiona Leslie and Polly Elkin who were patient and understanding as well as helpful. Most of the magnificent photographs were taken by Dominic Naish of our Photography Department, and the rest by members of that section.

I must also thank Mary Butler, Head of V&A Publications, Miranda Harrison, Managing Editor, and Clare Davis, Publications Assistant, for their hard work, as well as my copy editor Diane Pengelly.